THE OFFICIAL
COOKBOOK

THE OFFICIAL
COOKBOOK

ISBN: 9781803368061

Published by
Titan Books
A division of Titan Publishing Group Ltd
144 Southwark St
London
SE1 0UP

www.titanbooks.com

First edition: October 2024
2 4 6 8 10 9 7 5 3 1

TM & © TOHO CO., LTD.

Did you enjoy this book? We love to hear from our readers.
Please e-mail us at: readerfeedback@titanemail.com or write to
Reader Feedback at the above address.

To receive advance information, news, competitions, and exclusive offers online,
please sign up for the Titan newsletter on our website: www.titanbooks.com

A CIP catalogue record for this title is available from the British Library.

Printed and bound in China.

 Cooking Time Difficulty Vegan/Vegetarian Pescatarian

GODZILLA

THE OFFICIAL
COOKBOOK

KAYCE BAKER

TITANBOOKS

目次
CONTENTS

INTRODUCTION

Ready yourselves, Godzilla fans, as we embark on a roaring, sizzling, and downright monstrous journey through the epic world of kaiju cuisine, all in the name of the King of the Monsters. Grab your apron, sharpen your knives, and prepare to take your tastebuds on a cinematic thrill ride through a kitchen that's about to become your very own monster-filled cityscape!

In the world of cinema, there are few franchises that have had the staying power and cultural impact of *Godzilla*. Since that fateful day in 1954 when the mighty King of the Monsters first emerged from the ocean depths, it has stomped and roared its way into our hearts, becoming a pop-culture icon of colossal proportions. And now it's time to bring the franchise into the kitchen (hopefully without breaking too many dishes).

Throughout this culinary adventure, we'll delve deep into the rich lore of the *Godzilla* franchise, extracting tasty tidbits of inspiration from the most fearsome monsters, the quirkiest aliens, and the most unforgettable moments that have made this series a staple of science-fiction cinema. Each recipe in this cookbook is designed to capture the essence of these beloved characters and the thrilling battles that have kept us on the edge of our seats for generations.

But don't worry—you won't need a laboratory full of mad scientists or access to alien technology to whip up these delectable dishes. This cookbook is designed for cooks of all levels, whether you're just starting out or a seasoned pro, and our easy-to-follow recipes and step-by-step instructions will guide you through every culinary adventure, ensuring that your dishes are as impressive as an all-kaiju showdown over Tokyo.

As you flip through the pages of this cookbook, you'll encounter familiar faces like Godzilla, Rodan, and King Ghidorah, as well as some lesser-known kaiju and aliens that have clawed their way into our hearts over the years. Each character has a unique story to tell, and we've translated those stories into recipes that capture their essence.

Don't fret, humans—we haven't forgotten you or your contributions to the *Godzilla* saga! You'll also find recipes inspired by the fishermen, the Azumi family, Infant Island residents, and the intrepid reporters who've documented the kaiju chaos.

Whether you're planning a kaiju-themed movie night with friends or hosting a quirky dinner party, *Godzilla: The Official Cookbook* has all the recipes you need to create dishes that are as jaw-dropping as a Godzilla roar and as unforgettable as a Tokyo rampage.

Just remember—it's best to use a stove for most of these recipes (Godzilla heat rays not recommended for cooking).

ドリンク

DRINKS

The adventure begins with drinks that transport us from the depths of the ocean all the way through to the cool blue hue of Godzilla's heat ray. Whether you are on the lookout for a tasty libation or a simple, refreshing beverage, these recipes are the first stop on your kaiju journey through the heart of Tokyo as you await the next epic showdown.

深みから
FROM THE DEPTHS

There's no mistaking the furious bubbling that foretells its arrival. Sit back and relax with this refreshing cocktail as you look out to the sea and watch as Godzilla rises from its depths. And then maybe run.

Run a lime wedge around the rim of a 1-oz shot glass, dip the rim in sea salt. Fill it with melon liqueur. Fill a tankard with cold ginger beer and lime juice. Carefully drop the shot glass with melon liqueur into the beer, and watch it bubble up! (Serves 1)

INGREDIENTS

- 12 oz ginger beer
- 1 oz melon liqueur
- ½ oz lime juice
- Sea salt

 Active: 5 minutes Easy

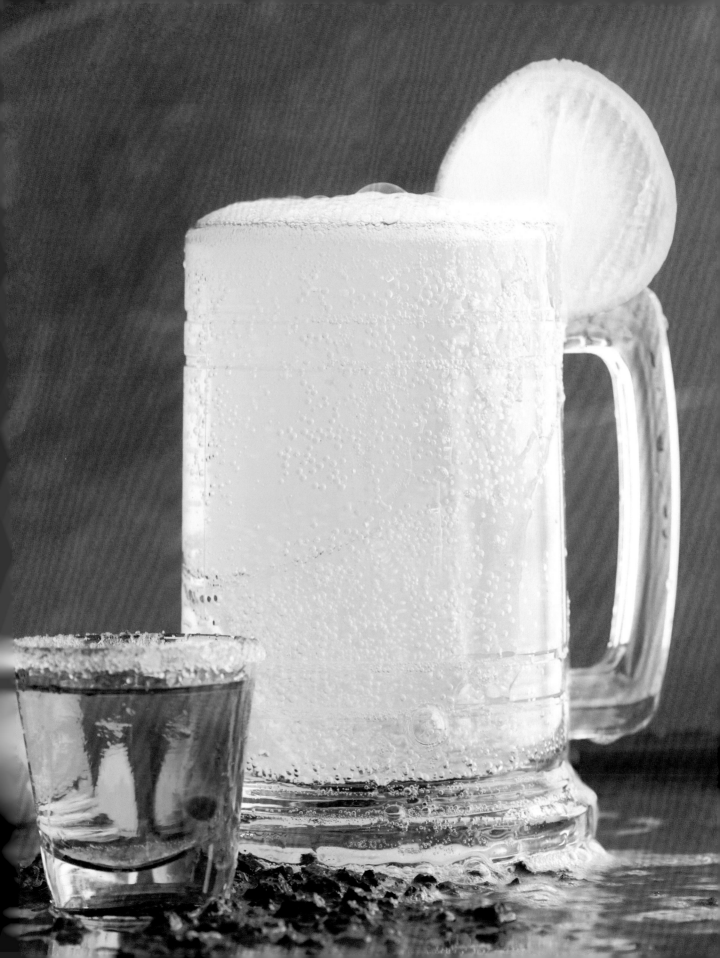

ゴジラの熱線

GODZILLA'S HEAT RAY

The cool, blue hue of this drink is reminiscent of the color of Godzilla's legendary heat ray!

Do not ingest or touch the dry ice. Add a small sliver of dry ice to the bottom of a martini glass. In a drink shaker, add ice, sake, and curacao. Shake, and pour into the martini glass. (Serves 1)

INGREDIENTS

- 4 oz dry sake
- 2 oz blue curacao
- Ice
- Dry ice (optional)

 Active: 3 minutes Easy

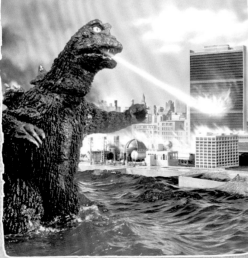

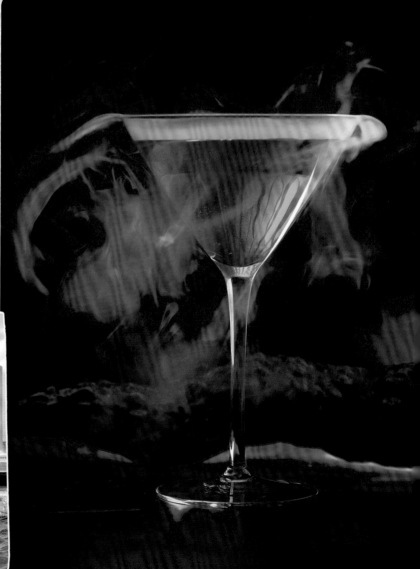

 12 *Godzilla: The Official Cookbook*

ゴジラのスパイラル熱線

GODZILLA'S SPIRAL HEAT RAY

Where the 'Godzilla's Heat Ray' drink reflects the color of the kaiju's breath, this one reflects how it might actually feel!

In a small bowl, add wasabi powder with a small amount of water to make a wasabi paste. Flip the bowl upside down and leave for roughly 10 minutes (more if you want your drink spicier). Add the paste to a drink mixer with the mint leaves and agave syrup, and muddle together with muddler or spoon. Add tequila and ice to mixer, shake and strain over ice cube in tall shot glass. (Serves 1)

INGREDIENTS

- 2 oz high-quality tequila blanco
- ¼ tsp wasabi powder
- ½ oz agave syrup
- Fresh mint leaves
- Ice

 Active: 12 minutes Easy

ラブル

RUBBLE

Tokyo is more often than not the target of all the kaijus' wrath, but with this breakfast staple the cleanup crew will have the energy to get the city ready for the next in-town showdown.

Add chia seeds to a small bowl with 2 tbsp coconut milk, then let sit until pudding consistency is reached. Add the raspberries, banana, almond milk, extract, and agave syrup to a blender and blend on low until you reach the desired consistency. Add more milk if needed. Spoon into bowls and layer on the rubble toppings. (Serves 2)

INGREDIENTS

- 1 cup frozen raspberries
- 1 small frozen banana
- ¼ cup almond milk
- ½ tsp vanilla extract
- 1 tbsp agave syrup
- 2 tbsp dark chocolate shavings
- 1 tbsp chia seeds
- 2 tbsp coconut milk
- 2 tbsp sweetened coconut
- 2 tbsp chopped walnuts
- 2 tbsp granola

 Active: 15 minutes Easy

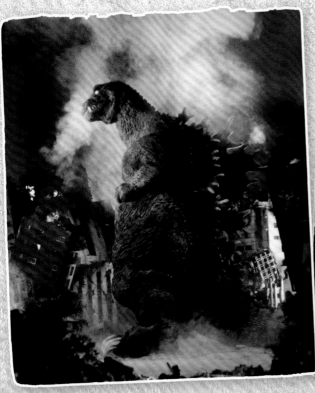

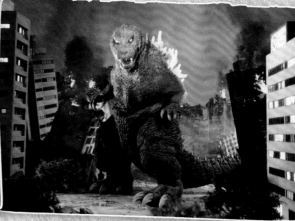

ゴジラのエネルギー補給
GODZILLA'S ENERGY BOOST

Even the King of the Monsters has to re-energize sometimes, and powerlines and generators are not always around. Luckily, it can rely on this energy-boosting drink, which has a little extra zing.

In a small drink mixer, add ice, ginger, turmeric, extract, lemon juice, and agave syrup. Shake vigorously until well blended. Add ice cubes to 2 12-oz glasses, strain the mixture into the glasses equally, and top off with 6 oz cold seltzer water. Serve with lemon wedge and get ready for that energy jolt! (Serves 2)

INGREDIENTS

- 1 tsp grated ginger
- ¼ tsp turmeric powder
- ½ tsp vanilla extract
- 2 tbsp fresh lemon juice
- 2 tbsp agave syrup
- 1 12-oz can seltzer water
- Ice

 Active: 5 minutes Easy

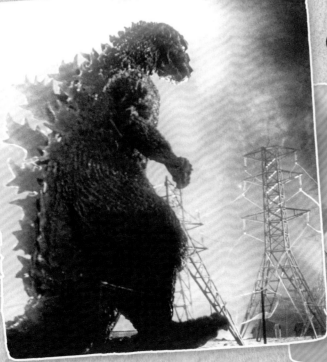

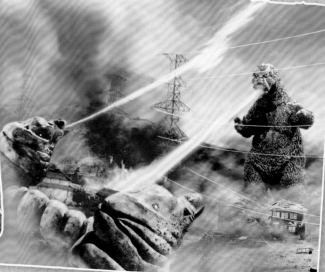

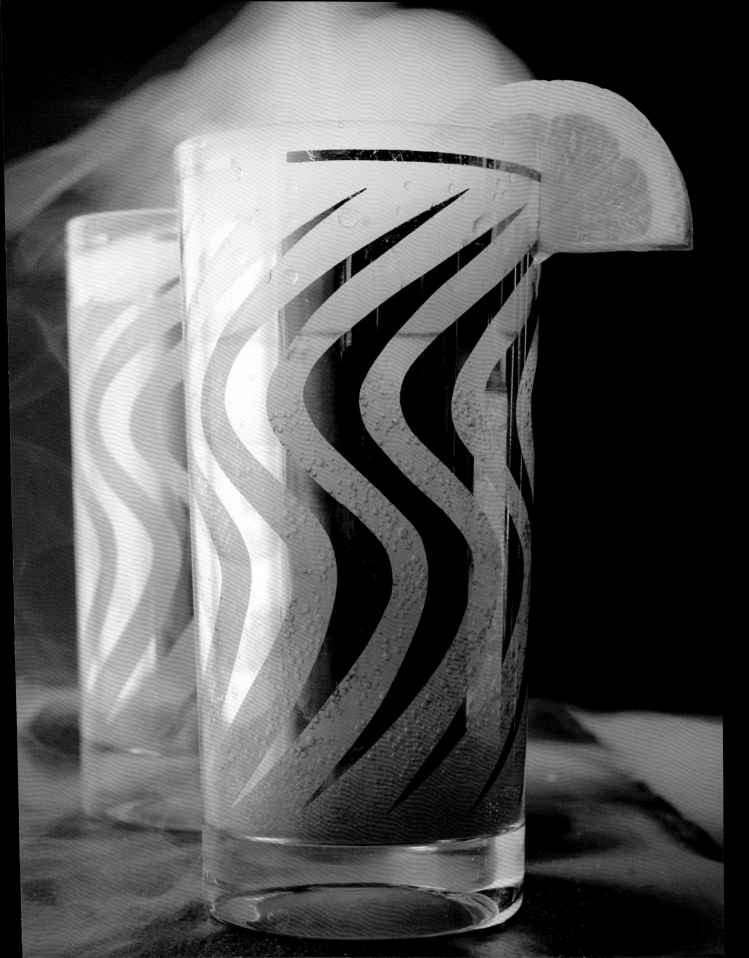

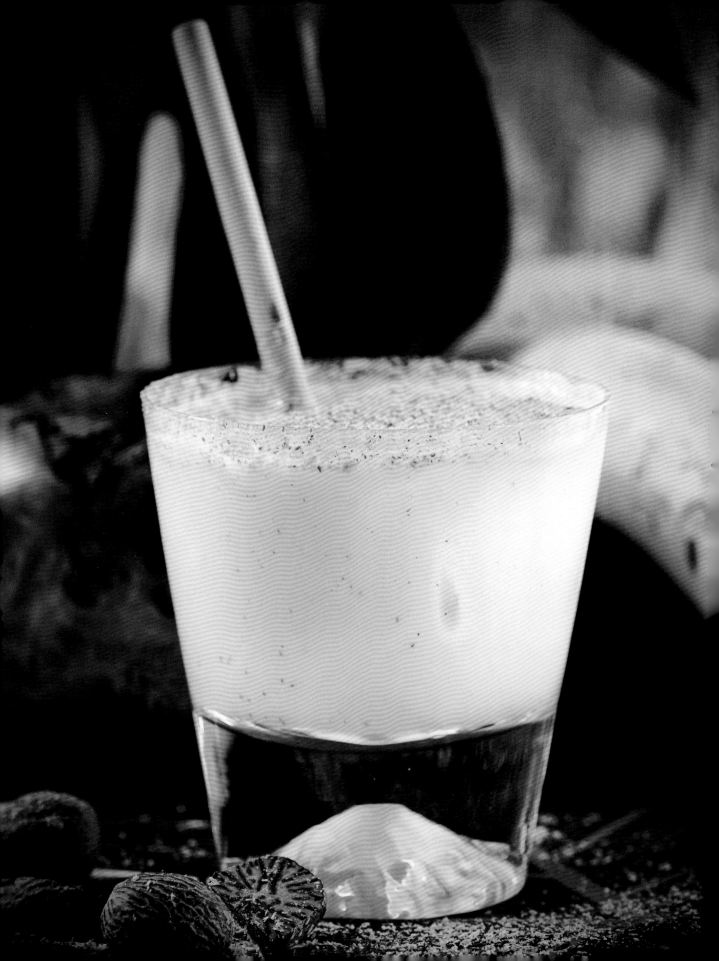

レッチ
THE LETCHI

There are lots of bananas to be had on this little island—perfect inspiration for this creamy drink.

Add ice, coconut, banana liqueur and bitters to a shaker. Strain over ice in a rocks glass. Top off with nutmeg. (Serves 1)

INGREDIENTS

- 2 oz coconut cream
- 2 oz crème de banane liqueur
- Dash of orange bitters
- Pinch of nutmeg

 Active: 3 minutes Easy

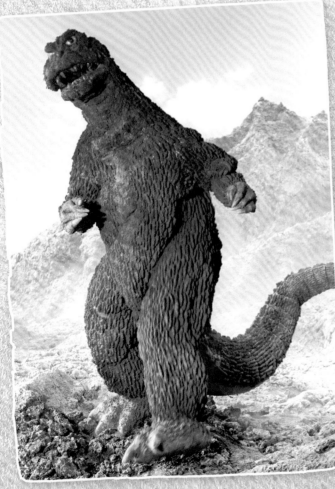

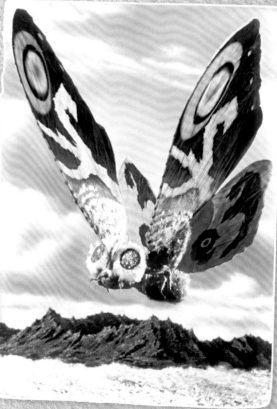

ガイガンズ　アイ
GIGAN'S EYE

Gigan's metallic beak is menacing enough, but that baleful red eye has inspired its very own cocktail!

In a small saucepan, add the hibiscus flowers, along with 1 cup water. Bring to a boil over medium heat. Remove from heat and cover. Let it steep for 15 minutes. Add agave syrup to a glass container, and strain the hibiscus concentrate into the glass container. Stir to combine the syrup with the concentrate and let it cool for roughly 30 minutes. Add ice to a drink mixer, add 2 oz hibiscus concentrate and rum, shake, and strain into fluted glass with ice. Top off with seltzer water. (Serves 2-4)

INGREDIENTS

- ¼ cup dried hibiscus flowers
- 4 tbsp agave syrup
- 2 oz seltzer water
- 2 oz rum
- Ice

 Active: 1 hour Easy

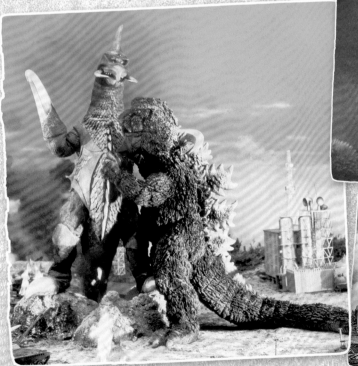

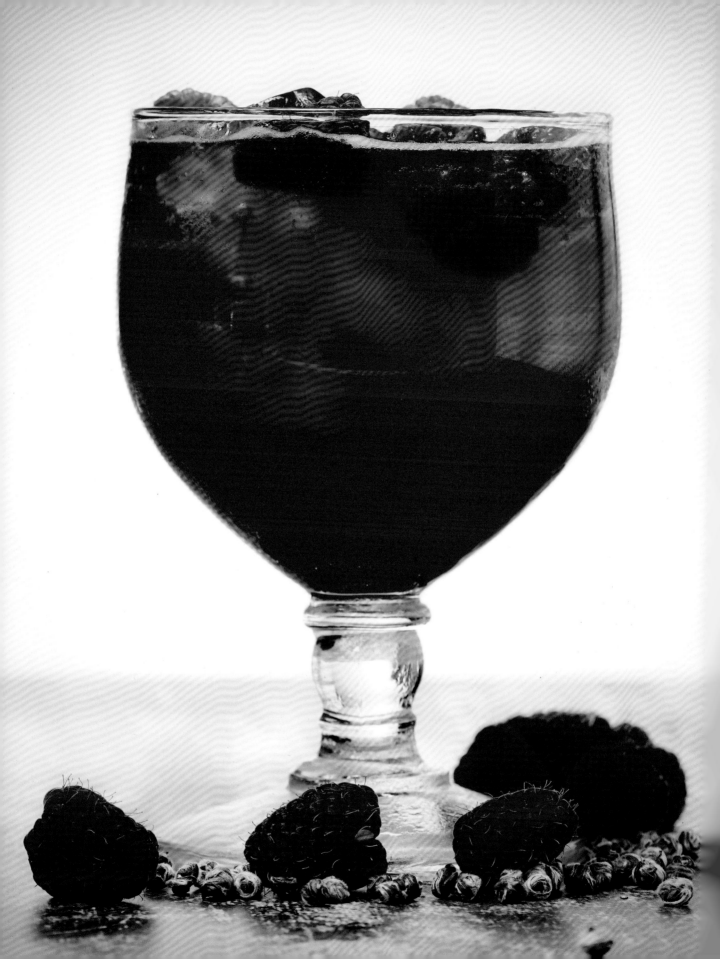

ワールド チルドレンズ ランド パンチ
WORLD CHILDREN'S LAND PUNCH

While the Space Hunter M Nebula aliens were busy using a Godzilla theme park as their base of operations, our brave Earth heroes were working hard to thwart their efforts. Celebrating their endeavors deserves a bright, tasty punch indeed.

Bring 6 cups water to a boil. Steep the tea in a kettle or other heatproof container. In a large glass container, add the honey or syrup. Once the green tea has steeped for 15 minutes, strain into the container with the honey or syrup and stir to combine. Set aside to cool down (roughly 30 minutes), then add the lime juice. To serve, add ½ tbsp of grenadine to a punch mug with ice. Then add frozen raspberries and 1 cup of tea to a shaker, shake and strain over ice in the punch glass. Top off with fresh raspberries. (Serves 4–6)

INGREDIENTS

- 2 tbsp loose-leaf green tea
- 6 tbsp honey or agave syrup
- 3 tbsp lime juice
- 3 tbsp grenadine
- 1 cup frozen raspberries
- Fresh raspberries
- Ice

 Active: 1 hour Easy

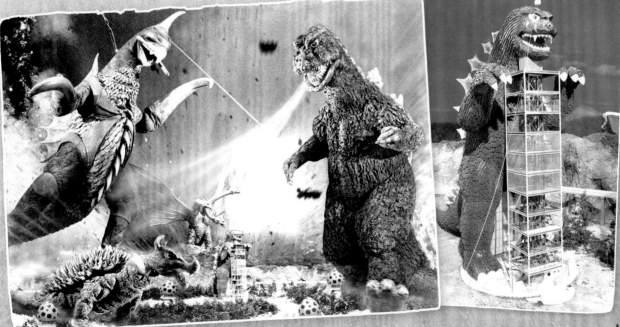

スペースチタンスリング
SPACE TITANIUM SLING

Mechagodzilla was created with Space Titanium, and with a few simple modifications to its molecular composition you too can create a concoction worthy of its own element.

In a drink mixer, add ice, sugar and rum, mix with a drink spoon. Add in the Chartreuse, blood orange liqueur, pineapple juice, lime juice, and orange bitters. Shake, and strain into 2 cocktail glasses. Top off with club soda, and garnish with edible gold. Stir and enjoy. (Serves 2)

INGREDIENTS

- 1 oz rum
- ¼ oz Chartreuse
- ¼ oz blood orange liqueur
- 1 tsp brown sugar
- 1 oz pineapple juice
- ½ oz lime juice
- 1 dash orange bitters
- ½ tsp edible gold
- Club soda, chilled, to top
- Ice

 Active: 5 minutes Easy

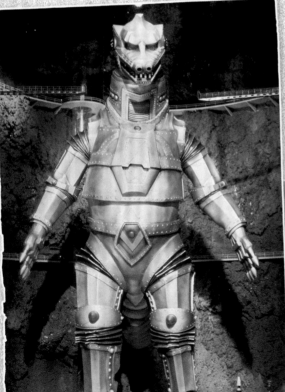

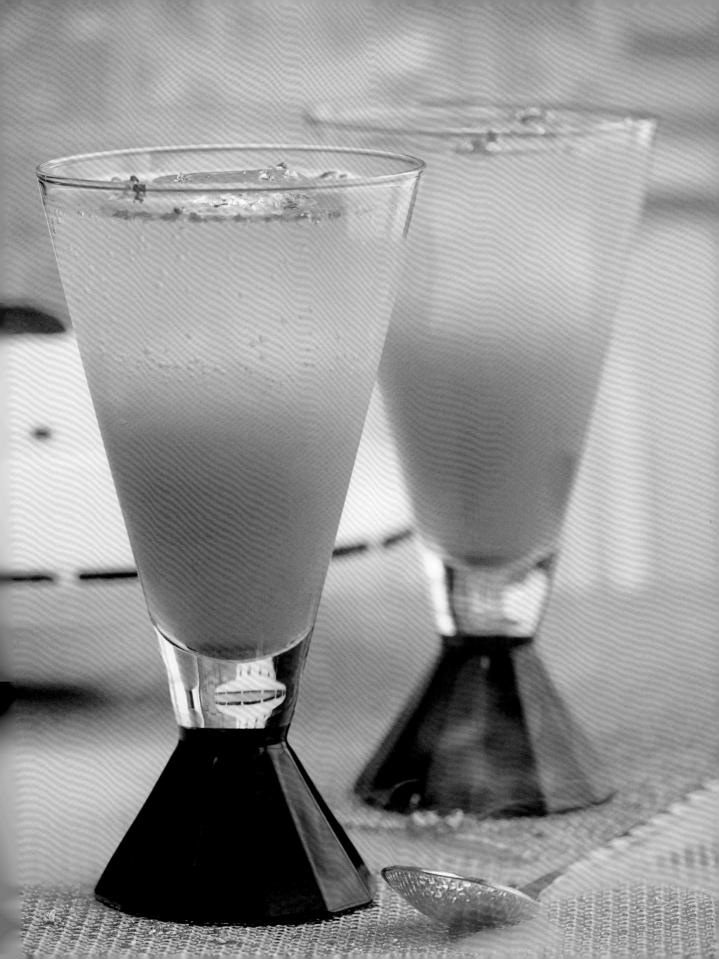

プラネット3カクテル
PLANET 3 COCKTAIL

Black Hole Planet 3 Simians seem to love this drink. Well, at least those in charge do—it helps with their sinister laugh.

Add ice, Midori, and tonic water to a rocks glass, and stir. Top off with honeydew wedge. (Serves 1)

INGREDIENTS

- 2 oz Midori
- 4 oz tonic water
- 1 honeydew wedge
- Ice

 Active: 3 minutes Easy

ヴィクトリー ダンス ツイスト
VICTORY DANCE TWIST

Godzilla loves a good celebration, so snap, crackle, and jump with this lively concoction!

Add popping candy to the bottom of an 8–10 oz glass. Add the rest of the ingredients except the ginger beer, along with some ice, into a shaker, stir, and then add the ginger beer. Pour ingredients into the glass with ice and popping candy and stand back! (Serves 1)

INGREDIENTS

- 1 oz pineapple juice
- 1 oz lime juice
- 1 oz Chartreuse
- 4 oz ginger beer
- 1 tbsp pineapple popping candy
- Ice

 Active: 5 minutes Easy

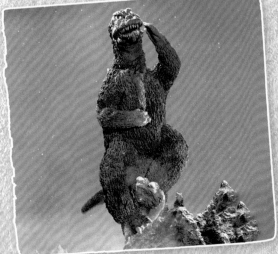

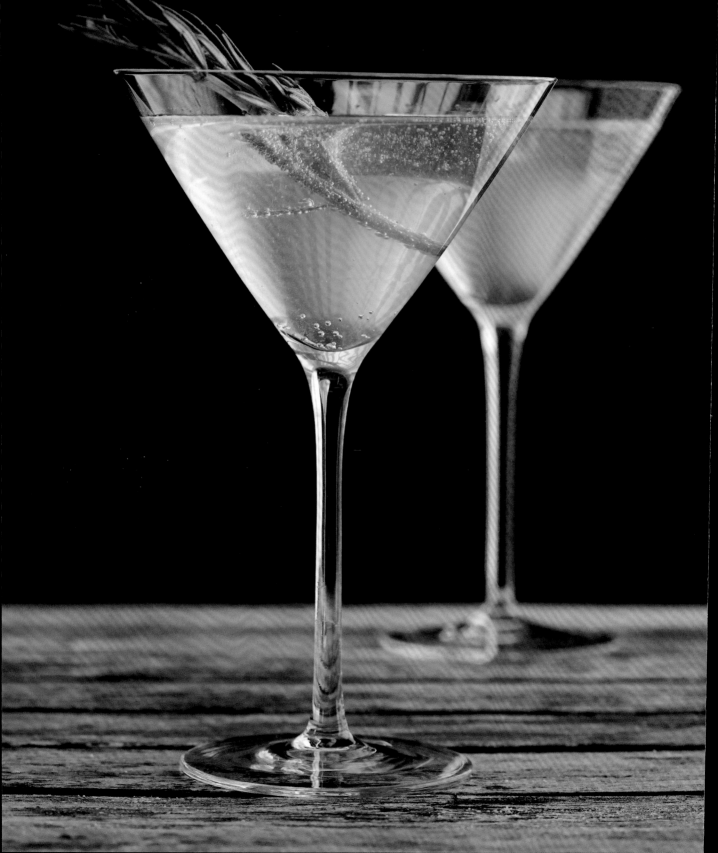

GPNについて
THE GPN

Predicting earthquakes is one thing, but predicting when Godzilla will arise from the sea and strike next? That is a job for the GPN (Godzilla Prediction Network), and this is one of their favorite tipples.

In a drink mixer, add half the leaves from the rosemary sprig and the salt. Using a muddler, muddle the rosemary leaves. Add ice, tequila, and lime juice. Shake, and strain into 2 martini glasses. Top off with ginger beer and rosemary sprig. (Serves 2)

INGREDIENTS

- 2 oz tequila reposado
- 2 oz lime juice
- 8 oz ginger beer
- ¼ tsp sea salt
- 1 sprig rosemary
- Ice

Active: 3 minutes Easy

オキシジェン　デストロイヤー
THE OXYGEN DESTROYER

Dr. Serizawa's invention solved the original Godzilla problem. This version doesn't do that, but it will solve any thirst problem!

In a shot glass, layer the drink by adding grenadine, tequila and lastly the blue curacao. Top with lime wedge.(Serves 1)

INGREDIENTS

- ½ oz blue curacao
- 1 oz tequila reposado
- ¼ oz grenadine
- Lime wedge

 Active: 3 minutes Easy

哲夫サウンドデバイス スムージー

TETSUO SOUND DEVICE SMOOTHIE

Tetsuo Torii's inventions were questionable until his round, compact device, designed to ward off assailants, finally paid off—much to the Xiliens' detriment.

Slice the dragon fruit open crosswise and save one slice. Scoop out the rest of the pulp and set aside in a small bowl. Add 1 tsp agave syrup and mix gently. Add the remainder of the ingredients into a blender and blend till smooth. Add dragon fruit mixture to bottom of a large cocktail glass, and pour smoothie over it. Top off with sliced dragon fruit and serve with a straw. (Serves 1)

INGREDIENTS

- 1 dragon fruit
- 1 cup frozen mango
- 1 cup coconut milk
- 2 tbsp + 1 tsp agave syrup
- ½ tsp vanilla extract
- 1 banana

 Active: 10 minutes 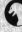 Easy

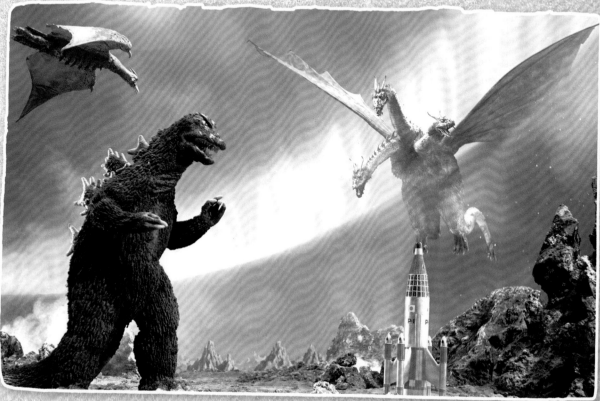

プラネット×ゴールドルーム
PLANET X GOLD ROOM

This tropical blend is the perfect reminder of how much the Xiliens seem to love their gold. We wanted to make sure you didn't see double when enjoying this beverage, so we omitted the alcohol. (If you see two Namikawas, you may want to run.)

Combine all ingredients in a blender, except the gold dust. Blend on high until thick, with a good smoothie consistency. Pour into square-shaped glasses and top off with gold dust. (Serves 2)

INGREDIENTS

- ½ cup frozen pineapple pieces
- 1 cup pineapple juice
- 1 tbsp frozen orange juice concentrate
- ½ cup coconut milk
- 1 banana
- ½ tsp turmeric powder
- 1 tbsp agave syrup
- edible gold dust

 Active: 15 minutes Easy

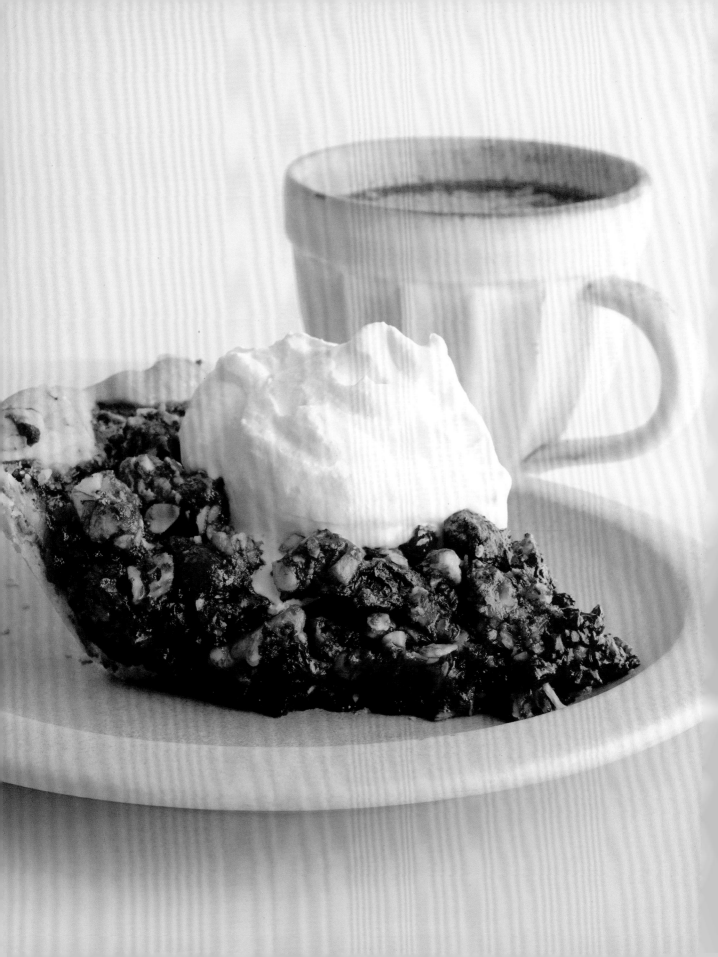

ブルーマウンテン チョコレート コーヒー

BLUE MOUNTAIN CHOCOLATE COFFEE

The most ordered drink at the Shibuya Diner. Order with a side of cherry-cranberry pie (see page 137).

Make coffee as you normally would with your coffee maker or French press. In a small saucepan, add the coconut milk, cream of coconut, palm sugar, and chocolate powder. Set heat to low and, using a whisk, mix everything together until fully blended. Do not allow to boil. Fill coffee mugs with two-thirds coffee and one-third milk chocolate mixture. Top off with cinnamon. (Serves 2–4)

INGREDIENTS

- 8 tbsp ground Jamaican
 Blue Mountain coffee
- 4 tbsp dark chocolate powder
- 1 tsp cinnamon
- 2 tbsp coconut palm sugar
- 1 cup cream of coconut
- 1 cup coconut milk

 Active: 15 minutes Easy

前菜

APPETIZERS

The second stop on our kaiju culinary tour is, of course, the starters. We can't have a full, multi-course *Godzilla* viewing party without a full assortment of tantalizing appetizers to start the rampage!

ロダン　クローズ
RODAN CLAWS

Even more feared than its wings, Rodan's claws have been known to hurl boulders, trees, and other deadly objects with pinpoint accuracy, momentarily stunning other kaiju.

1. In a large bowl, toss the finely shredded cabbage with salt, enough to quickly coat, and let sweat for 10 minutes.

2. In a medium skillet, add 2 tbsp sesame oil and cook the ground pork for 2 minutes. Add chipotle powder and cilantro, continue to cook until pork is cooked thoroughly, set aside to cool. When pork has cooled, squeeze excess moisture from cabbage, drain bowl, and add in the rest of the Filling ingredients along with a touch of salt. Mix well.

3. On a sheet of parchment paper, lay a dumpling wrapper, and place 1 tsp filling in the center. Moisten the edges of wrapper and fold the wrapper so the edges meet to form a semi-circle. Pinch the edges closed with your fingers to seal the dumpling. Repeat to make 40 gyoza.

4. In a large frying pan with lid, heat pan over medium heat, add 2 tbsp sesame oil, coating the pan well. Align 20 gyoza in a tight pattern in the pan. Add ¾ cup water, cover with lid, and proceed to steam dumplings on medium heat for 6-8 minutes until translucent and all liquid is gone. Remove lid and cook for another minute or two so that the bottoms of the dumplings have been essentially 'fried'. When done, place a large plate over the pan and carefully flip the dumplings over. Serve with dipping sauce (page 151). (Serves 6-8)

INGREDIENTS

Filling:
- 2 cups napa cabbage, finely shredded
- 1 ½ cups ground pork
- ¼ cup chives, minced
- 1 tbsp carrot, finely diced
- 1 garlic clove, minced
- 1 tbsp ginger root, grated
- 1 tbsp chopped cilantro
- ¼ tsp chipotle powder
- 2 tsp soy sauce
- 2 tbsp sesame oil
- 1 tsp salt

Dumplings:
- 20 dumpling wrappers
- 2 tbsp sesame oil

 Active: 1 hour Complex

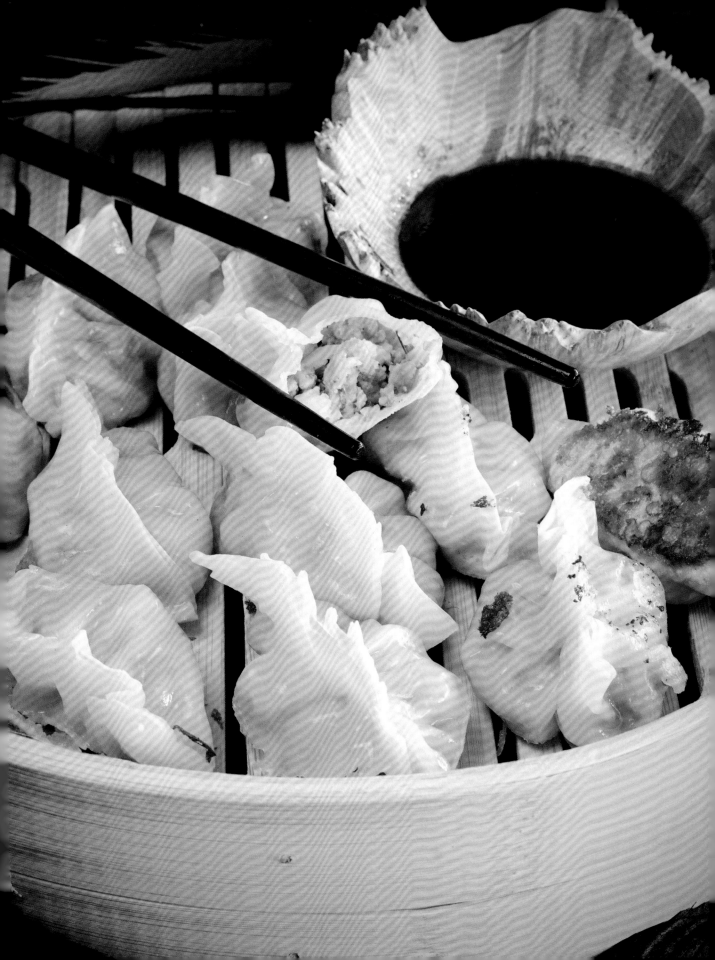

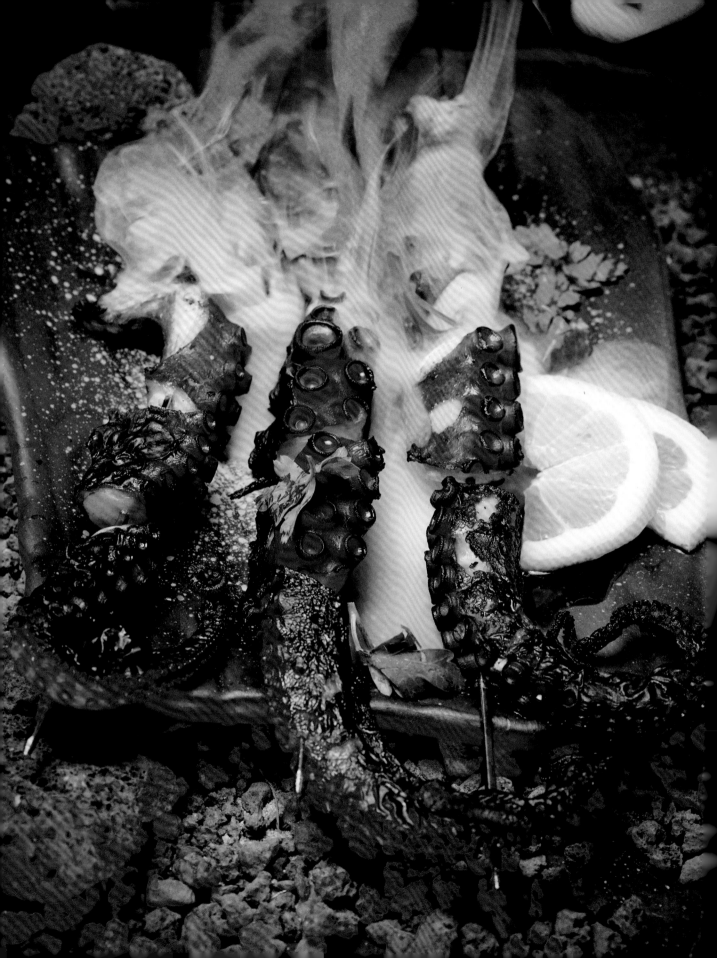

大蛸
OODAKO

Rising from the ocean depths, this 'Devil of the Sea' appeared suddenly, taking aim at the villagers of Faro Island. It was ultimately cast back into the sea... with a few pieces left for a delicious yakitori.

1. Wash octopus in cold water and place in a sealable plastic bag or medium baking dish. Mix sake, mirin, soy sauce, yuzu, lime juice, and garlic in a small bowl and add to bag or dish.

2. Marinate octopus in refrigerator for 2 hours, making sure to rotate every 30 minutes to cover all the octopus evenly. If using wooden skewers, soak wooden skewers in water for about 30 minutes.

3. Preheat grill. Remove octopus from marinade and wipe off marinade with paper towels. Cut up octopus into 2-in pieces and slide onto skewers. Oil the grill grate and place skewers directly on the grill, being careful not to have them fall in-between the grates. Grill for 3–4 minutes on each side. Serve immediately with a drizzle of ponzu sauce and chopped parsley. (Serves 2)

INGREDIENTS

- 4 pre-cooked octopus tentacles
- ¼ cup sake
- ¼ cup mirin
- ¼ cup soy sauce
- 1 tbsp yuzu juice
- 1 tbsp lime juice
- 2 cloves of garlic, minced
- 1 tsp chopped parsley
- 1 tbsp ponzu sauce

 Active: 2.5 hours Easy

ゴジラ アイズ
GODZILLA EYES

What lurks behind those monstrous eyes, pure destruction or yummy goodness? These gator-filled eyeballs solve the mystery as soon as you devour one, two or several.

1. For the batter, combine all the batter ingredients in a large bowl and set aside.
2. Remove the silver skin from the gator tenderloins and cut into small ½-in pieces. Place in small bowl and coat evenly with flavorings. In a medium frying pan, add 1 tbsp vegetable oil and cook gator evenly for about 5 minutes. Remove and place on paper towel to drain oil.
3. Place takoyaki plate on stove over medium heat, add small amount of oil in each hole. Place a piece or two of gator in each, then fill up the holes with the batter mix. Slight overflow is fine. Add chopped chives and tenkasu to each hole.
4. Cook takoyaki for about 2-4 minutes until batter is cooked and looks like it's separating from the pan, prepare to flip. Using a small wooden skewer, poke the outside of the cooked batter and flip it over within the hole. It takes time to cook the entire ball, so be patient. Keep an eye on the non-cooked sides and keep flipping until entire ball is cooked evenly and golden brown on all sides (about 8-10 minutes total). Serve with takoyaki sauce, bonito flakes and Japanese mayonnaise. (Serves 4)

INGREDIENTS

Batter:
- ⅔ cup flour
- 2 eggs
- 2 cups water
- ¼ tsp smoked paprika
- 1 tbsp dashi stock

Filling:
- ½ cup fresh gator tenderloin
- ¼ cup chives, chopped
- ¼ tsp onion powder
- ¼ tsp garlic powder
- ¼ tsp cayenne pepper
- ¼ tsp oregano
- ¼ tsp salt
- ¼ tsp cumin powder
- 1 tbsp tenkasu
- Vegetable oil

Toppings:
- Takoyaki sauce (see page 153)
- Japanese mayonnaise
- Bonito flakes

Special equipment: Takoyaki plate

 Active: 30 minutes Complex

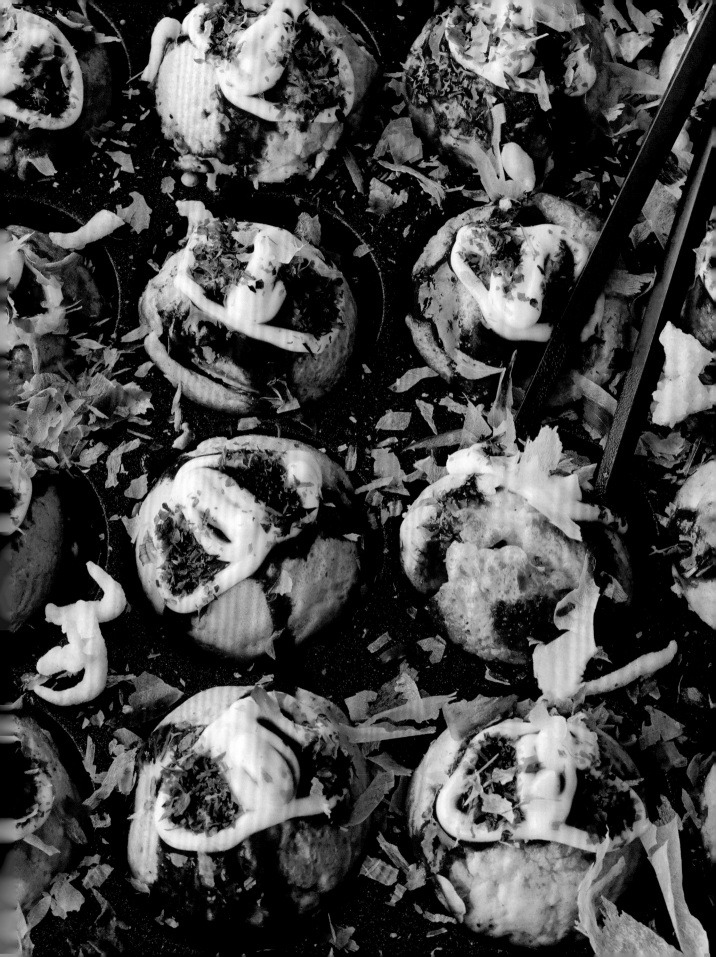

ロダン ネスツ
RODAN NESTS

Be careful not to disturb or take any eggs from these nests on Adonoa Island, for you may find yourself on the wrong side of a very angry flying monster.

1. Using a food processor, grate all the carrots into shreds. In a medium bowl, add the carrots, chopped pear, and mayonnaise. Mix together well, cover, and let stand in refrigerator for 1 hour.
2. Remove from refrigerator and, using an ice cream scoop, place large scoop of carrot salad on plate, indent center, and serve with 1 chopped date in the middle. (Serves 6)

INGREDIENTS

- 4 cups heirloom or orange carrots, grated
- 1 large Asian pear, cored and chopped
- ⅓ cup Japanese mayonnaise
- 6 dates, roughly chopped

 Active: 30 minutes
Inactive: 1 hour
 Easy

海
UMI

All life comes from the sea, including Godzilla. This simple soup lets us savor the complexity that is the birthplace of the King of the Monsters.

1. Clean and cut the mushrooms into stems, set aside. In a medium saucepan over high heat, add dashi and water; bring to a boil.
2. Reduce heat to medium, whisk in miso paste, and add in the mushrooms. Cook for 2 minutes. Add the spring onions, and simmer for 3 minutes. Serve with thinly sliced dried nori. (Serves 6)

INGREDIENTS

- 3 tsp dashi soup powder
- 4 tbsp white or yellow miso paste
- 1 pack enoki mushrooms
- 2 spring onions, sliced diagonally
- 3 sheets of dried nori (seaweed)

 Active: 20 minutes

 Easy

 Vegan

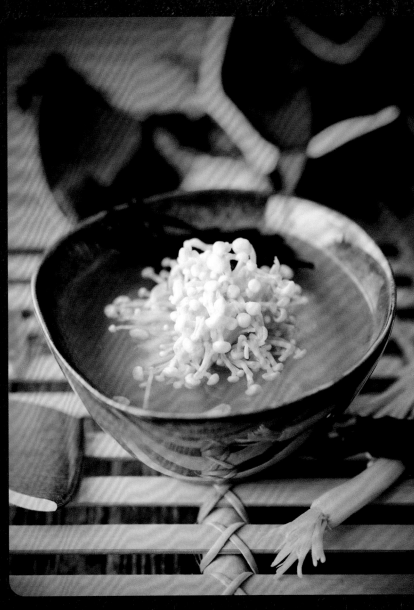

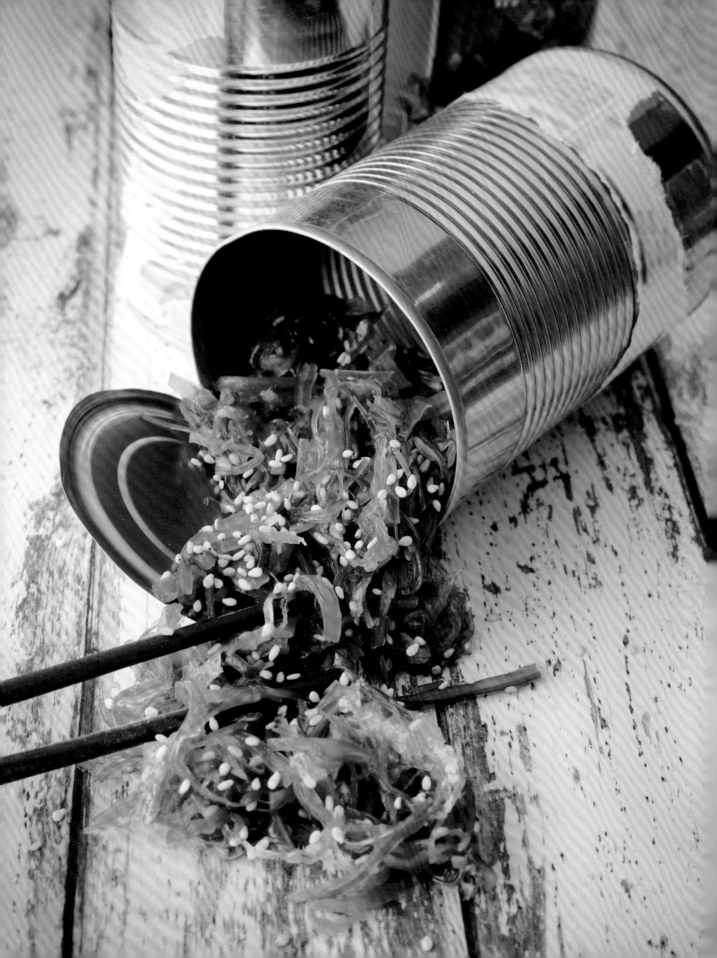

ヤーリーン缶のり
YAHLEN CANNED SEAWEED

Stowing away on a yacht to save your brother? Well, if you look in the cabinets for provisions you might just be able to whip up this simple dish.

1. Soak the wakame in warm water for 10 minutes. Whisk together all remaining ingredients, except the sesame seeds, for the dressing.
2. Drain the wakame and squeeze out all the liquid possible. Slice it into strips, add to medium bowl with dressing, add green onion and cucumber, and coat well. Serve with sesame seeds. (Serves 2)

 Active: 30 minutes Easy Vegan

INGREDIENTS

- 1 cup raw kelp
 (wakame seaweed, rehydrated)
- 2 tbsp sesame seeds, toasted
- 1 tbsp tamari
- 1 tbsp mirin
- 2 tsp sesame oil
- 2 tsp rice vinegar
- 2 tsp ginger, grated
- 2 tsp agave syrup
- ¼ tsp ancho chili powder
- 1 tsp green onion, thinly sliced
- 1 tbsp English cucumber,
 thinly sliced and julienned

With its monster flavor, it's easy to see why this is a must for kaiju movie night.

1. In a small food processor, combine the onion, pine nuts, and garlic. Cut avocados lengthwise, carefully scoop out pulp into a medium bowl, leaving just a thin internal rim of avocado on the skins, and set skins aside. Add cilantro, lime juice, hot sauce, onion mixture, and salt to avocado, and mash.

2. In a serving bowl, place the bottom halves of the avocado skins and fill with guac, take the top halves, cut out eye sockets, and place diced onion pieces inside. Add pine nuts inside to make teeth. Serve with guac and tortilla chips. (Serves 3)

 Active: 10 minutes Easy Vegan

INGREDIENTS

- 3 large ripe avocados
- 1 tbsp pine nuts
- 1 clove garlic, minced
- ¼ white onion, chopped
- 1 tbsp cilantro, chopped
- 1 tbsp lime juice
- 1 tsp hot sauce
- Salt to taste
- Tortilla chips

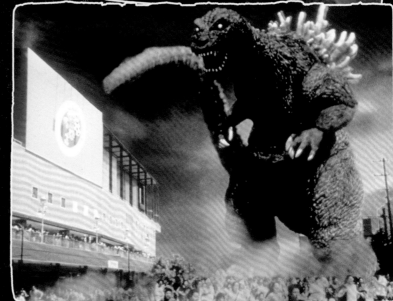

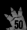

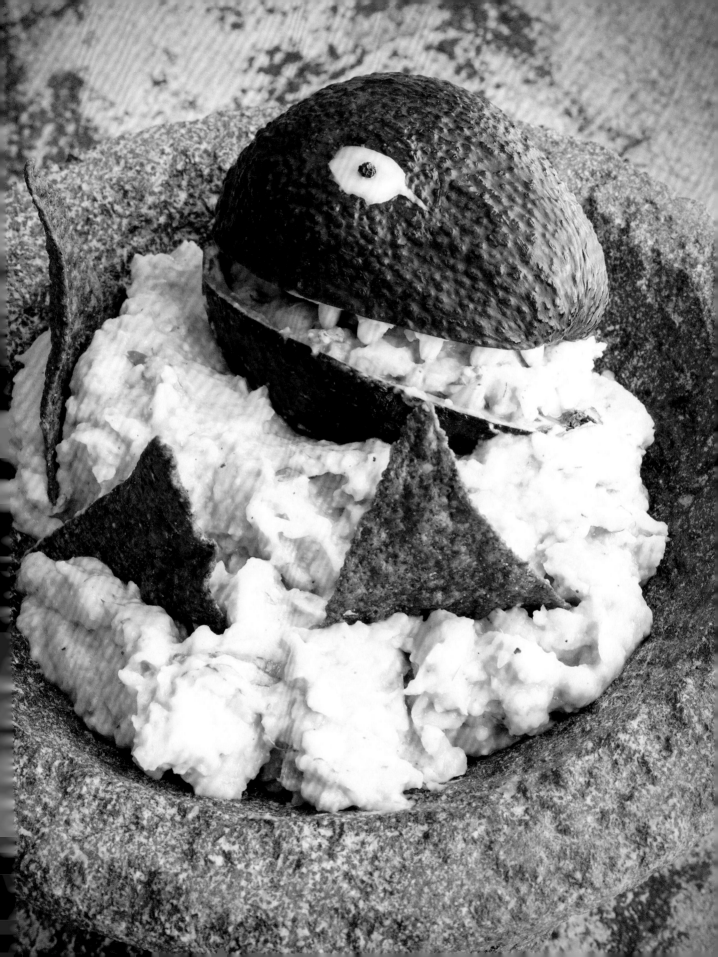

モスラのたまご
MOTHRA EGGS

These eggs won't be found on any beach—and most certainly will not be part of any theme park—but they will be a popular attraction in your kitchen.

1. Add raw eggs to a medium pot, and cover with cold water and 2 tbsp vinegar. Bring to boil on high heat and continue boiling for 2 minutes. Remove from heat, cover pot, and let stand for 20 minutes.

2. In the meantime, chop up bacon into small pieces. In a small saucepan over medium heat, cook bacon until it is just starting to crisp, stirring occasionally. Remove pan and drain half the grease out. Return to stove over low heat, and add brown sugar and balsamic vinegar to bacon. Stir to combine, and continue cooking until mixture becomes caramelized (about 3 minutes).

3. Remove from heat. Using tongs, remove bacon and place on paper towel to drain for 2 minutes. Remove and place on small plate to cool.

4. Remove eggs from water, place a paper towel on the counter, gently roll eggs, and remove shells. Slice eggs in half lengthwise, and scoop out cooked yolks into a medium bowl. Set aside.

5. In a medium bowl, add blue food coloring and 4 cups water. Place sliced eggs in the bowl with the blue liquid and let stand for 5 minutes. Remove from blue liquid, wash off lightly, dry eggs, and place on serving tray.

6. Add mayonnaise, sugar, white vinegar, mustard powder, Worcestershire sauce, sweet pickle juice, sweet pickle relish, and salt to the egg yolks, and mix well with a fork. Using a spoon or small scoop, fill egg halves with yolk mixture. Top off with candied bacon bits and dust with paprika. (Serves 4)

INGREDIENTS

- 6 eggs
- 2 tbsp Japanese mayonnaise
- 1 tsp sugar
- 1 tsp white vinegar
- ½ tsp mustard powder
- 1 tsp Worcestershire sauce
- 1 tsp sweet pickle juice
- 1 tbsp sweet pickle relish
- Dash of salt
- Paprika to taste
- 1 tbsp blue food coloring

Bacon:
- 1 strip bacon
- 2 tsp brown sugar
- 1 tbsp balsamic vinegar

 Active: 30 minutes
Inactive: 2 hours

 Easy

モスラの羽
MOTHRA WINGS

Mothra's wings were powerful enough to help save the wounded Godzilla from King Ghidorah, but these wings are a light and delicate salty snack.

1. Preheat oven to 325°F. Prepare baking sheet with parchment paper. Arrange nori shiny side down on the baking sheet.
2. Lightly brush coconut oil over nori, season with salt, Tajin, and lime crystals. Bake for 5-10 minutes till desired level of crisp is attained.

INGREDIENTS

- 2 sheets nori, cut into Mothra shapes
- 1 tsp coconut oil
- Black salt to taste
- Dried lime crystals
- Tajin

 Active: 20 minutes Easy Vegan

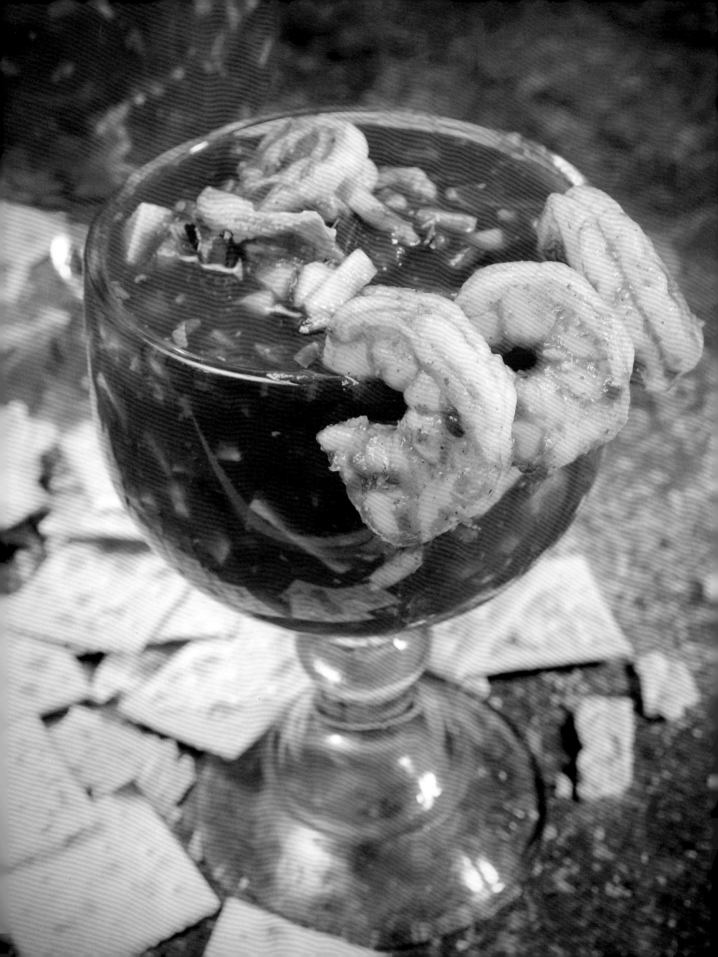

エビラ カクテル
EBIRAH COCKTAIL

Unsuspecting ships are no match for this kaiju. Ebirah patrols the waters off Letchi Island, instilling fear in local natives and sailors alike. However, thanks to Godzilla we have a few pieces of it left for this flavorful and spicy cocktail.

1. Add ice and water together in a large bowl to make an ice bath. In a medium saucepan, add water, onion, and garlic powder, along with ½ tsp salt, and bring to a boil. Add shrimp, cook for 3-4 minutes to make sure they're cooked through but not rubbery. Turn off heat, remove shrimp with slotted spoon, and add to ice bath. Set aside to cool.
2. Add all diced ingredients to a large bowl, mix with ¼ tsp salt and minced garlic. Mix all liquid ingredients and oregano together in a separate bowl. Combine everything but the shrimp and refrigerate for 1 hour.
3. Remove from refrigerator and add the shrimp, mix in chopped avocado before serving with crackers or tortilla chips.

Homemade Clamato:
Combine 2 cups tomato juice, ½ cup clam juice, 2 tsp coconut aminos, 2 tbsp lemon juice, ¼ tsp celery salt, 2 tsp hot sauce, and ½ tsp fresh ground black pepper in shaker, and shake until mixed thoroughly. Store in refrigerator for up to 5 days.

INGREDIENTS

- 2 lbs (16-20) shrimp, peeled and de-veined
- 2 large Roma tomatoes, diced
- ½ small red onion, diced
- ½ cup cilantro, chopped
- ½ English cucumber, diced
- ¼ jalapeno, seeded and diced
- 2 garlic cloves, minced
- ½ white onion
- ¼ tsp onion and garlic powders
- Salt
- 2 cups Homemade Clamato (see left)
- 1 tbsp ponzu sauce
- 2 tsp coconut aminos
- ½ cup ketchup
- 1 tsp dried oregano
- 1 tsp hot sauce
- 4 tbsp lime juice
- 2 avocados, chopped
- Saltines

 Active: 2 hours Easy

メインディッシュ

ENTREES

It's time for the main course! Sink your teeth into the Godzilla Loaf, a footprint of meatiness that will leave a monster impression on your tastebuds. Or fly into some Tacos al Rodan if you're feeling like something light. Craving something crispy? Try Kaiju Tempura, the ultimate fusion of crunch and creature. The sea calls as well, with the Ebirah Salad Roll. And for those who can appreciate the meteoric arrival of Monster Zero, give King Ghidorah Arrives or Meteorites a try; they are sure to pack a triple punch of flavor.

ゴジラ ローフ
GODZILLA LOAF

Godzilla leaves an imprint wherever it goes. This meaty loaf can be made with any type of ground meat, but the key is making sure you shape its foot just right. Will you add three toes or four?

1. Preheat oven to 375°F. Combine all ingredients in a large bowl, except the onion wedges. Using food-safe gloves, massage all until it is a consistency that can be shaped.

2. Prepare a cookie sheet with parchment paper and fresh parsley stalks. Shape the meat loaf into a three- or four-toed Godzilla foot. Place an onion wedge on each toe to simulate claws. Bake for 35-40 minutes until crispy and internal temperature is reached for your type of ground meat.

3. Remove from oven and brush the top with glaze. Place back in the oven for 5 minutes. Remove, serve with extra glaze. (Serves 6)

INGREDIENTS

- 1 ¾ lbs ground meat
- ¼ cup parmesan cheese
- 2 cups rice, cooked
- ½ cup parsley, chopped
- 2 eggs
- 1 tsp garlic powder
- 1 tbsp coconut aminos
- 1 tbsp dark soy sauce
- 1 tsp salt
- 1 tsp ground pepper
- 1 tbsp hoisin sauce
- 1 tsp oregano
- 2 tbsp ketchup
- ½ cup onion, chopped
- 3 onion wedges
- Glaze – Kaiju Sauce (page 150)

 Active: 1.5 hours Easy

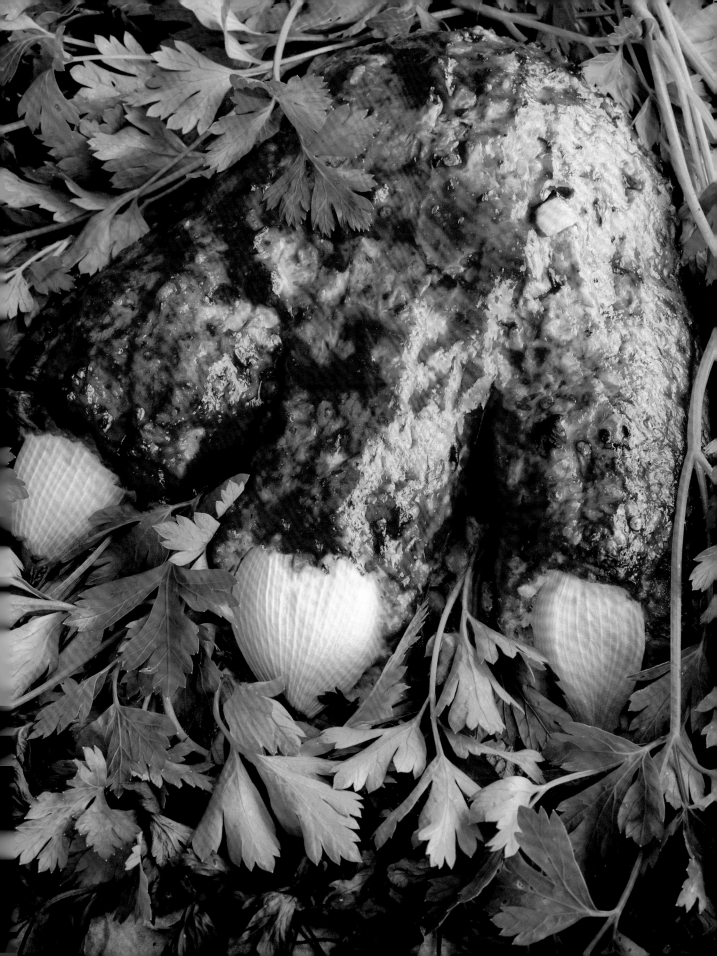

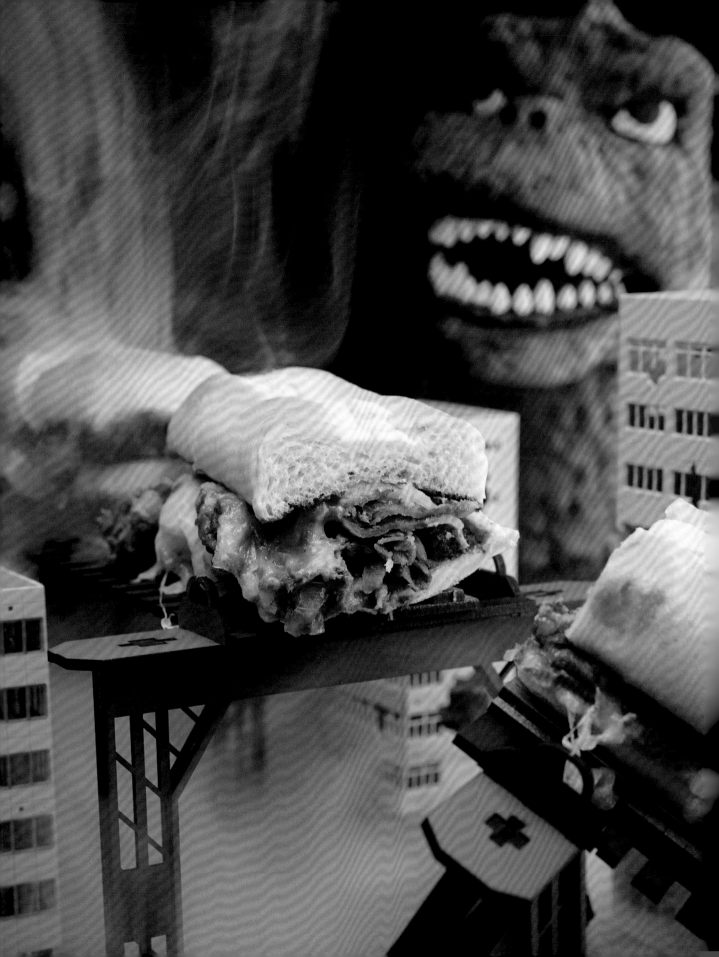

東京の車内サンドイッチ
TOKYO TRAIN CAR SANDWICH

Sadly, they never seem to be able to stay on the tracks... Like so many Tokyo train cars in every kaiju encounter, we are certain these sandwiches won't stay on their plates too long either.

1. Add the Hondashi to 1 ½ cups hot water and dissolve. In a medium bowl, whisk together the sake, garlic powder, coconut aminos, mirin, soy sauce, and the dashi soup you just made. Add the sugar and whisk till dissolved.

2. In a medium pan with a lid, add the sliced onions in one layer. Add the sliced beef on top of that layer, and cover with the liquid. Turn on the heat to medium to get to a simmer, and then cover the pan. Simmer for 4 minutes, remove lid, skim any fat off the top, and then add the ginger and give a stir. Cover the pan again and simmer for 2 minutes, remove from heat and let stand.

3. In the meantime, pre-heat your oven's broiler setting. Set up a cookie sheet with aluminum foil, lightly butter each half of the sub bread and place on the foil, cut side facing up, and add to the broiler to toast for about a minute.

4. Remove from oven and set top halves aside. Spoon the meat mixture onto the bottom half of the bread and cover with cheese. Place under the broiler to melt the cheese, remove when cheese has desired level of char and melt. Top with other side of the bread and slice into 2 or 4 equal pieces. Enjoy alone or with chips. (Serves 2-4)

INGREDIENTS

- 1 lb beef, thinly sliced
- 1 large Vidalia onion, sliced
- 1 tbsp sake
- 1 tsp garlic powder
- 1 tbsp coconut palm sugar
- 1 ½ tsp Hondashi powder
- 3 tbsp mirin
- 3 tbsp soy sauce
- 1 tbsp coconut aminos
- 1 tsp fresh grated ginger
- 1 cup Monterey Jack cheese
- 2 tbsp butter
- Sub bread

 Active: 40 minutes Easy

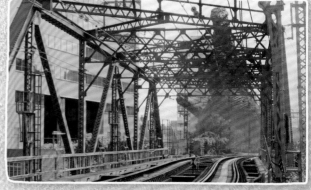

カイジュウテンプラ
KAIJU TEMPURA

With monster-sized flavor and a light, crispy breading, this tasty, light treat is sure to satisfy any kaiju appetite.

1. Prepare alligator by removing the thin silver skin on the tenderloins to make sure it's not too chewy. With a knife, carefully slice them down the center as if to fillet them. With the two halves, slice them in half so you have 4 pieces total (roughly 2 in long). Dry them on paper towels and set aside until ready to fry. Prepare veggies and set aside.
2. Heat oil to 350°F in a deep fryer or heavy-bottomed pot. Set up a draining station with a wire rack over a cookie sheet with paper towels.
3. For the batter, mix together the flour, breadcrumbs, cornstarch, cayenne pepper, salt, nori, and club soda in a medium bowl. Coat alligator in batter, and deep fry until light golden brown (roughly 5-7 minutes). Internal temperature for gator should be 170°F.
4. Using a spider strainer, remove gator from oil and drain on wire rack. Add the vegetables to the batter and repeat frying process (fry till golden brown—about 2-3 minutes depending on vegetable). Drain and serve with steamed rice and tempura sauce (page 151). (Serves 2-4)

INGREDIENTS

- ½ lb alligator tenderloin
- 1 small sweet potato, skinned and sliced
- 1 small sweet onion, sliced
- 1 cup all-purpose flour
- 1 cup panko breadcrumbs
- 1 cup cornstarch
- ½ tsp cayenne pepper
- 1 tsp salt
- 2 tsp dried nori, crushed
- 2 cups club soda
- 3 cups vegetable oil
- steamed rice

 Active: 40 minutes Easy

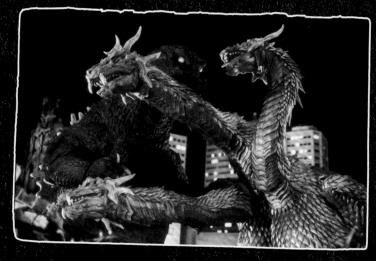

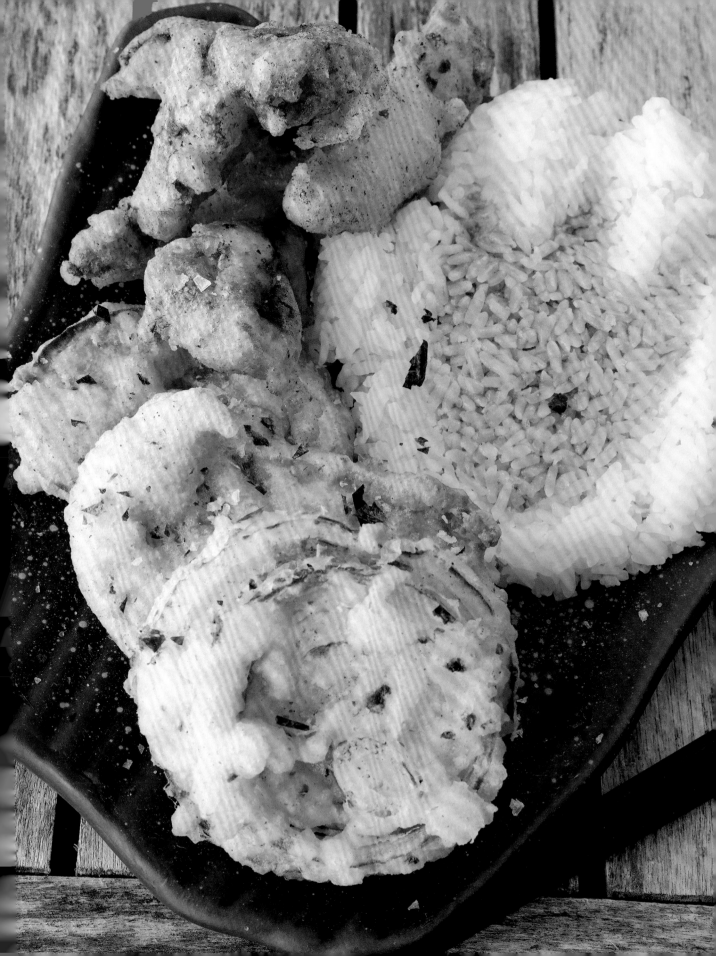

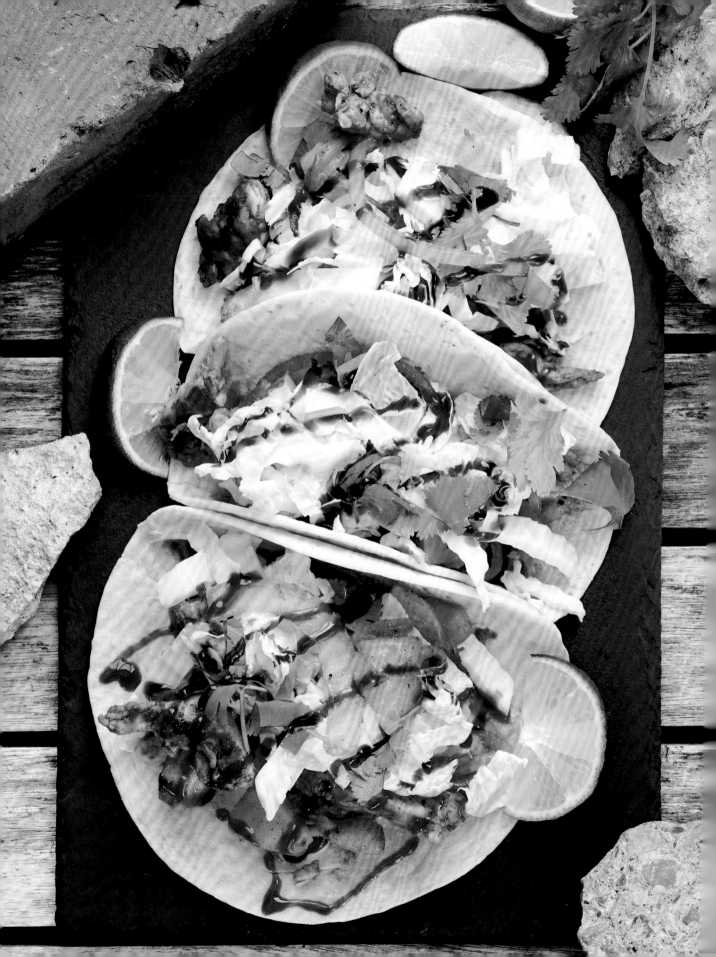

タコス　アル　ロダン
TACOS AL RODAN

These flavor-packed tacos are the perfect main course for any Rodan fan. Unlike the real monster, you won't have to go to a distant island to find them, just your kitchen.

1. Slice chicken breasts in half lengthwise. Using plastic wrap and a meat tenderizer, tenderize each piece so that they flatten out into cutlets. Slice the cutlets into half-inch strips. In a medium bowl, combine Guajillo chili powder, garlic powder, onion powder, ginger powder, oregano, salt, and pepper; toss chicken strips in, coat and set aside.

2. In a medium bowl, toss Napa cabbage and Japanese mayo together and set aside.

3. Preheat griddle on medium-high heat. Heat sesame oil in wok, add seasoned chicken and sliced onion to oil, and cook until cooked through (roughly 5 minutes).

4. While chicken is cooking, place tortillas on griddle and heat through on both sides, remove and keep warm. Before removing chicken from wok, add the pineapple bits at the last minute and toss for 30 seconds.

Serve immediately. Build tacos in the following order: tortilla, chicken, onions, pineapple, teriyaki glaze, Napa cabbage salad, top with sesame seeds and lime wedge. (Serves 2-4)

INGREDIENTS

- 2 boneless skinless chicken breasts
- ½ cup diced pineapple
- ½ white onion, thinly sliced
- 2 tbsp sesame oil
- ½ tsp Guajillo chili powder
- 1 tsp garlic powder
- 1 tsp onion powder
- 1 tsp ginger powder
- ½ tsp oregano
- ½ tsp salt
- ¼ tsp pepper
- 8 flour tortillas
- 1 tbsp cilantro, chopped
- 2 cups Napa cabbage, finely shredded
- 2 tbsp Japanese mayo
- 1 lime, sliced
- ¼ cup teriyaki glaze (see page 154)
- Sesame seeds

 Active: 45 minutes Easy

エビラ サラダ ロール
EBIRAH SALAD ROLL

Ebirah terrorized ship crews and islanders alike, so it may not come as any surprise that once defeated, pieces of this kaiju were destined to meet butter.

1. Add thawed lobster tails to a steamer and steam for 7 minutes. Remove, let cool and remove meat from shells (discard any shell pieces). Place lobster meat on doubled-up paper towels to dry any excess water.

2. In a medium bowl, mix the celery, mayonnaise, coconut aminos, dill, chives, yuzu, lemon zest, and pepper. Taste for seasoning and add salt if needed. Heat up griddle. Butter the insides of the buns, then toast on hot griddle for about 3 minutes until golden brown. Fill buns with lobster salad, serve with potato chips. (Serves 2-4)

INGREDIENTS

- 4 5-7-oz frozen cold water lobster tails, thawed
- ¼ cup celery, minced
- ¼ cup mayonnaise
- 1 tsp coconut aminos
- 1 tbsp dill, minced
- 1 tbsp chives, minced
- 1 tbsp yuzu juice
- 1 tsp lemon zest
- ¼ tsp pepper
- Salt to taste
- 4 split-top brioche buns
- 4 tbsp butter
- Potato chips

 Active: 20 minutes Easy

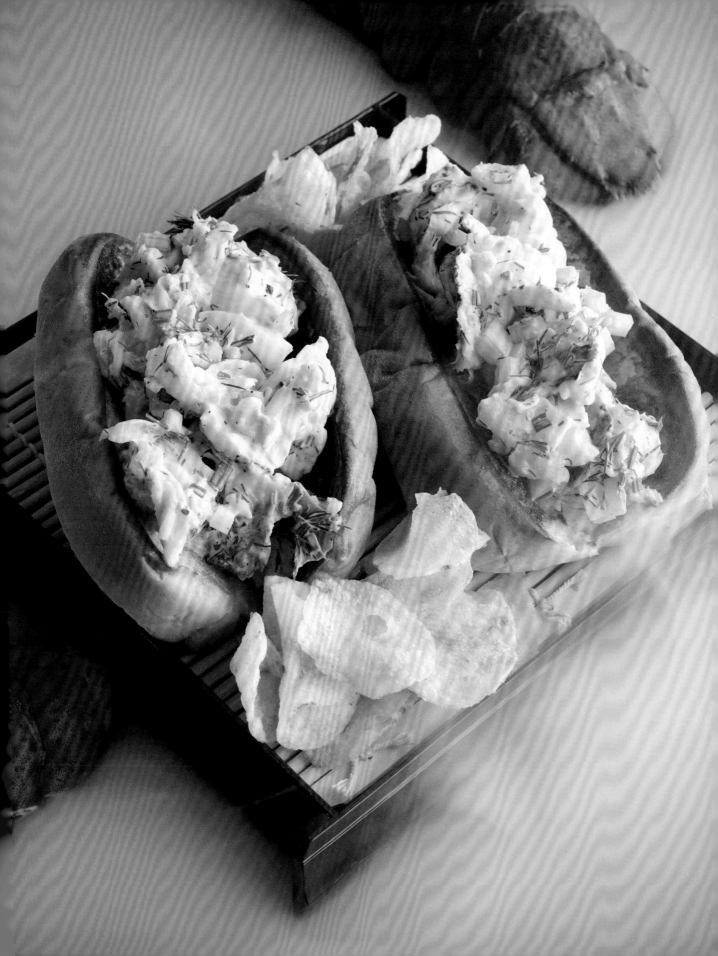

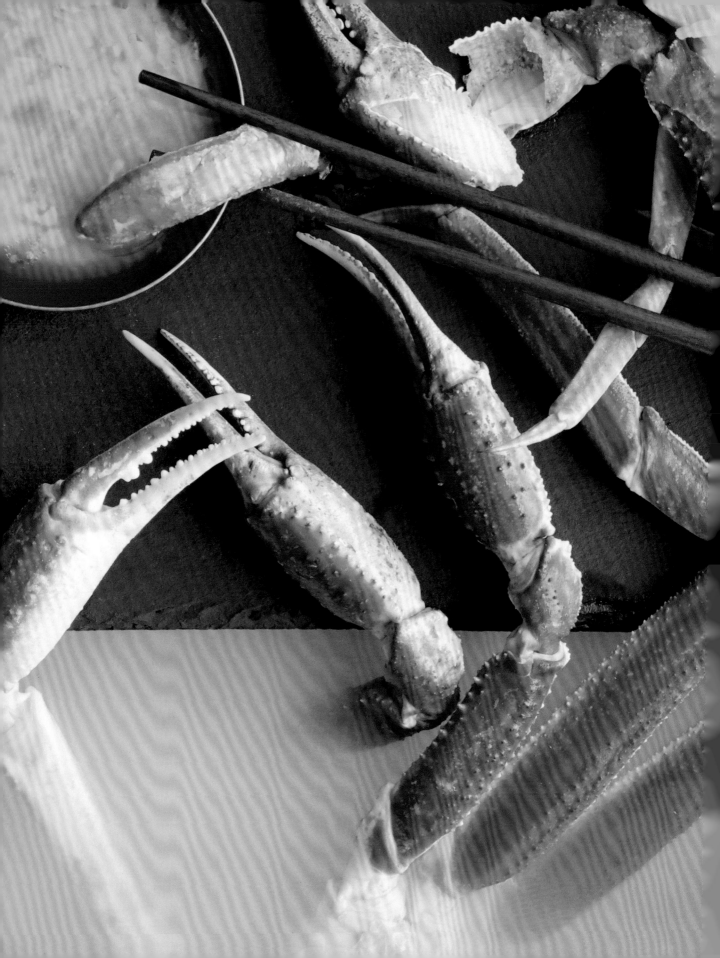

エビラクローズ
EBIRAH CLAWS

These claws, inspired by the Horror of the Deep, will really grab your tastebuds' attention!

1. Thaw out the crab legs before cooking if you are using frozen ones. Melt 2 tbsp butter in a medium saucepan, add ginger, garlic, and shallots, and cook for about 2 minutes over medium-low heat. Add sake, bring to a boil, and reduce liquid by about half.

2. Add cream, bring to a boil. Add the pepper flakes and, using a whisk, add the remaining butter 2 parts at a time, and whisk until incorporated. Continue to add and whisk in butter until mixture is thick and creamy.

Remove from heat, whisk in yuzu and parsley, and season with salt.

3. Heat 10 cups water in a large stock pot. Add 1 tbsp salt and bring to a boil. Place claws into boiling water, and boil for 5 minutes. Remove from water and serve immediately with sauce and lemon wedges. If using pre-cooked crab legs, add water to the bottom of a stock pot with a steamer insert, bring to a boil, add legs, cover, and steam thawed legs for 8 minutes. (Serves 2-4)

 Active: 15 minutes Easy Pescatarian

INGREDIENTS

- 2 lbs fresh or frozen crab legs
- 6 tbsp chilled unsalted butter, cut into tbsp pieces
- 1 tbsp ginger, peeled and minced
- 1 tbsp garlic, minced
- 1 tbsp shallots, minced
- ½ cup good-quality sake
- 1 tbsp heavy cream
- ½ tsp yuzu
- ⅛ tsp pepper flakes
- 1 tsp parsley, chopped
- Finishing salt

隕石
METEORITES

The *Godzilla* movie franchise is replete with visitors from space. The most common and yet the most mysterious of them all? Meteorites. Who knows what dangers lurk in these extra-terrestrial planet crashers? No danger here, just a tasty, satisfying sandwich.

1. Add the baking soda to a quart of water, then add the cup of dried chickpeas and let stand 12–14 hours. Add the drained chickpeas, herbs, coconut aminos, onions, garlic, and spices to a food processor fitted with a blade. Process until cohesive falafel mixture is formed, scraping often. Transfer to a bowl, cover, and refrigerate for 2 hours.
2. Just before frying, mix in baking powder. Using a medium ice cream scoop, form falafel balls on a sheet of wax paper, set aside.
3. Preheat oil to 350°F in heavy-bottomed pan. Using a spider strainer, carefully place a few falafel balls in the oil (do not overcrowd), let them fry for about 5 minutes until crispy on the outside. Drain falafel on paper towels, and serve in pita bread with garlic sauce, chopped cucumbers, chopped tomato, pickled turnips, and tahini sauce.

INGREDIENTS

- ½ tsp baking soda
- 1 cup dried chickpeas
- 1 cup fresh parsley, no stems
- ½ cup fresh dill, no stems
- ¼ cup fresh mint, no stems
- 1 cup sweet onion, chopped
- 8 garlic cloves, peeled
- 1 tsp ground black pepper
- 1 tbsp ground cumin
- 1 tbsp oregano
- 1 tsp smoked paprika
- 1 tsp coconut aminos
- 1 tsp salt
- 1 tsp baking powder
- 3 cups vegetable oil for frying
- Garlic sauce (see page 154)
- 1 tomato, chopped
- 2 cups lettuce, shredded
- ½ cucumber, seeded, chopped
- Pickled turnips (see page 153)
- Tahini sauce

 Active: 30 minutes
Inactive: 12-14 hours

 Complex

 Vegan

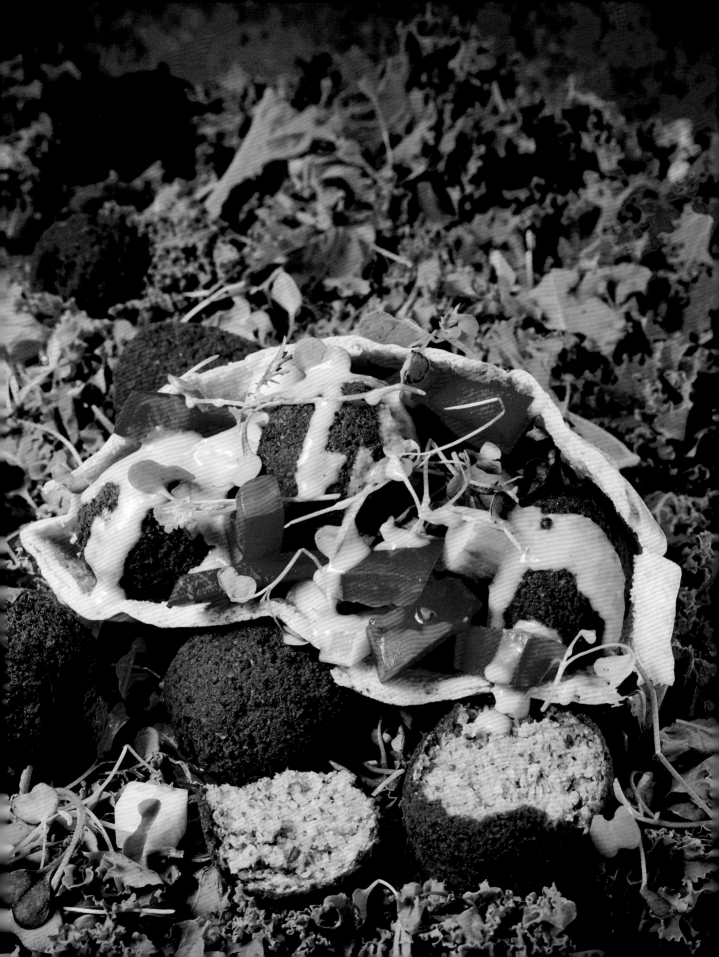

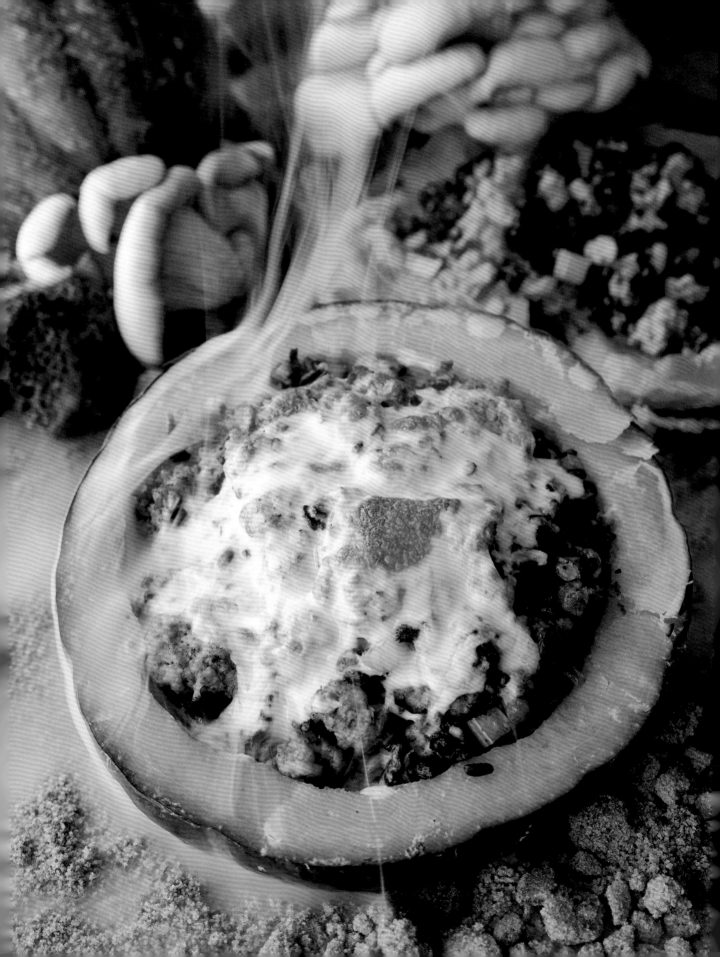

キングギドラ登場
KING GHIDORAH ARRIVES

Some meteors are more dangerous than others—this one had a dangerous traveler inside, much feared on Planet X and Venus. It's okay, though—Godzilla, Rodan, and Mothra had a plan for King Ghidorah.

 Active: 1.5 hours
Inactive: 1 hour

 Easy

1. In a small pot over medium heat, add forbidden (black) rice and chicken broth, and bring to a boil. Reduce heat to simmer, cover, and cook till done (about 20 minutes). Remove from heat, let sit for 10 minutes, fluff, and set aside.

2. Preheat oven to 400°F. Cut squash in half lengthwise, and de-seed. In a 9 x 13in casserole dish, add water to the bottom. Place squashes (cut-side down) in the water, tightly cover the dish with foil, and roast for 30-40 minutes or until fork tender.

3. While roasting, prepare the filling. In a large frying pan, add 1 tbsp olive oil. When hot, add ground pork to the pan and break it up with a cooking spoon. Add ½ tsp of salt and garlic powder to the pork and continue to cook until no longer pink (5-8 minutes).

4. Remove the pork from the pan and discard the liquids from the pan. Add 1 tbsp olive oil into the frying pan, heat, and add onion and celery. Sauté until onion is translucent, add mushrooms, pepper, and ¼ tsp salt, sauté for another 3 minutes. Remove from heat and add veggies to the pork and discard the liquid in the pan.

5. Place pan back on stove over medium heat, add 1 tsp olive oil, and add the rice to it. Quickly fry the rice, stirring constantly for 2 minutes, transfer the pork and veggies into the pan, mix, cook for another minute, turn off heat, and set aside.

6. Remove squash from oven, drain water, wipe clean, and spray with cooking spray. Add squash halves to the casserole, puncture the squash with a fork, and season with a little olive oil and a dash of salt. Fill the squash with filling, top with cheese, place back into oven. Bake for 10 minutes or until cheese is melted. Serve immediately. (Serves 2)

INGREDIENTS

- 1 large kabocha squash
- 1 tbsp olive oil
- ½ tsp salt

Stuffing:

- 2 tbsp olive oil
- ½ cup sweet onion, diced
- ½ lb ground pork
- 1 large stick celery, diced
- ½ cup forbidden (black) rice
- 1 ½ cups chicken broth
- ¼ tsp black pepper
- ½ cup shiitake mushrooms, chopped
- 1 tsp salt
- ½ tsp garlic powder
- ½ cup Monterey Jack cheese

ガイガンズウィングズ

GIGAN'S WINGS

Those giant dorsal fins would be hard to ignore were it not for Gigan's lethal buzzsaw blades and cybernetic claws. Still, after being defeated so many times, you'd think the Nebulans and Xiliens would enslave a different monster to do their bidding.

1. For the sauce, combine the coconut water and cornstarch in a small bowl and set aside. Stir together the sugar, salt, and curry powder in a medium saucepan over low heat. Add in the coconut water slurry, butter, lemon juice, yuzu juice, and zest, stir over low heat until thickened. Remove from heat and set aside to cool.

2. On a large clean plate, place chicken pieces and season with salt and pepper. Set up three dredging stations. In the first station, mix flour, onion powder, and paprika. In a small bowl, whisk together the egg and Worcestershire sauce and add to second dredging station plate. In the third one, add the panko breadcrumbs.

3. In a large frying pan, heat up the oil to about 350°F, making sure it's not too hot. Add each piece of chicken and fry each side for 4 minutes or until golden brown and internal temperature is 165°F. Serve with lemon curry sauce, lemon slices, and rice. (Serves 2-4)

 Active: 40 minutes Easy

INGREDIENTS

- 2 large skinless, boneless chicken breasts, cut in half and pounded to ½-inch thickness
- 2 tbsp all-purpose flour
- 1 tsp onion powder
- ½ tsp smoked paprika
- 1 egg
- 1 tsp Worcestershire sauce
- 1 cup panko breadcrumbs
- 1 cup vegetable oil for frying
- Salt and pepper
- Lemon slices

Sauce:
- 2 tbsp lemon juice
- 1 tbsp yuzu juice
- ⅛ tsp yellow curry powder
- ½ tbsp cornstarch
- ¼ cup sugar
- 2 tbsp butter
- Zest of half a lemon
- ½ cup coconut water
- Dash of salt

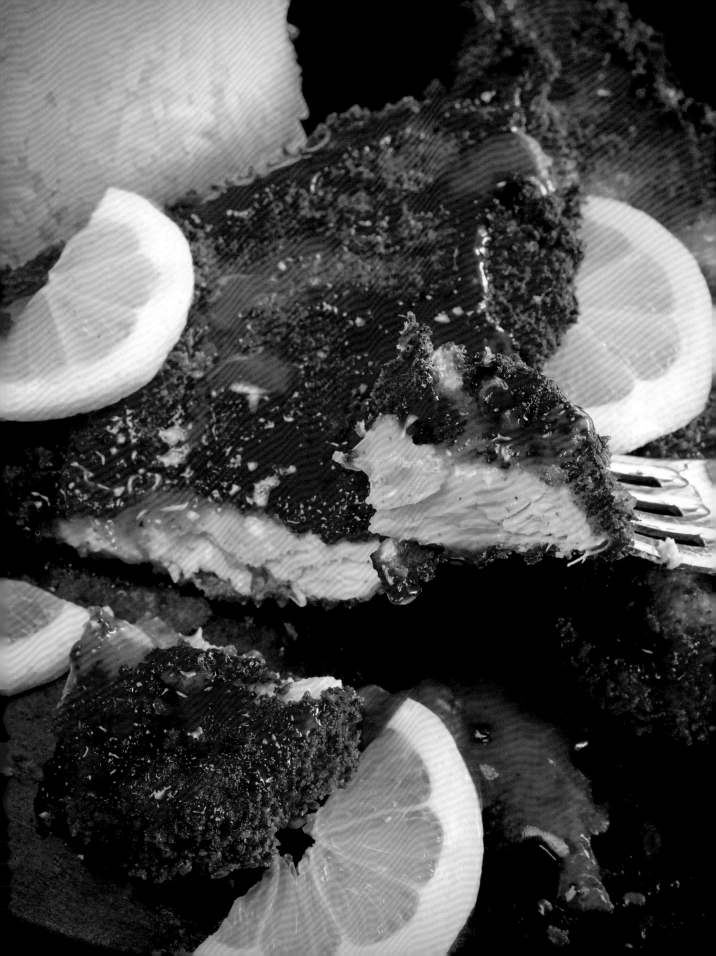

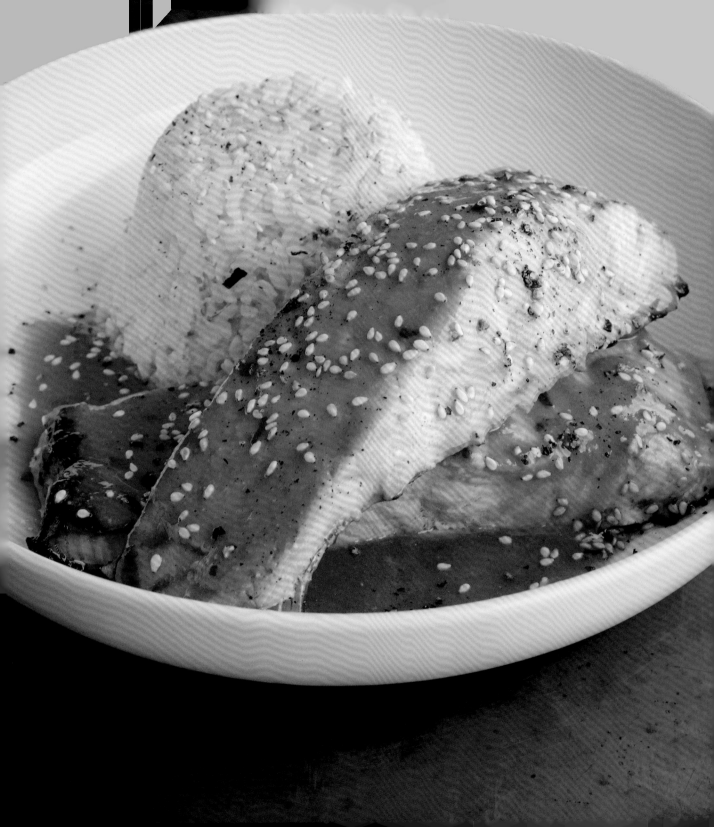

シートピアサーモン
SEATOPIA SALMON

The Seatopians may have a beef with the surface-dwelling humans, but they sure do make a tasty fish dish.

1. Start with room-temperature fish. Move oven rack to upper third of the oven. Set oven to 500°F. In a medium bowl, whisk the miso, soy sauce, rice vinegar, agave syrup, sesame oil, red pepper flakes, and salt until smooth.
2. Line a large baking sheet with aluminum foil. Spray it with cooking spray. Pat the salmon dry and place it skin-side down on the baking sheet. Brush salmon with half the miso mixture. Place in oven and bake for 10 minutes.
3. Turn on broiler and crisp top of salmon for 3-4 minutes (thermometer should read 130°F). To serve, brush with remaining miso mixture, and sprinkle with sesame seeds and fresh ground pepper. (Serves 4-6)

INGREDIENTS

- 4 salmon fillets with skin
- 2 tbsp white miso
- 2 tbsp soy sauce
- 1 tbsp rice vinegar
- 1 tbsp agave syrup
- 1 tbsp sesame oil
- ¼ tsp red pepper flakes
- ¼ tsp salt
- Fresh ground pepper
- Sesame seeds

 Active: 30 minutes Easy Pescatarian

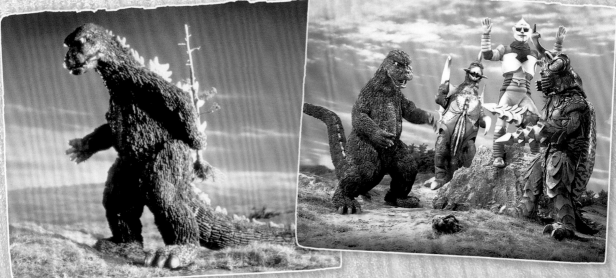

フィッシャーマンズ ランチ
FISHERMAN'S LUNCH

Fishermen are often the first to encounter Godzilla. It's important they have a satisfying meal to keep alert.

1. Clean, de-vein, and de-shell shrimp, leaving tails on. To keep shrimp from curling, add 4 notches to the bellies of the shrimp with a small knife. Sprinkle the shrimp with salt, and then add them to medium bowl and toss with the cornstarch.

2. In another medium bowl, whisk together egg, coconut aminos, and ¾ cup cold water. Whisk in flour (do not overmix). Spread the panko breadcrumbs on a separate plate.

3. In a medium pot, heat oil to 350°F. Dip each shrimp in batter, then coat with panko, then place in the oil. Fry as many shrimps as you can at a time without overcrowding, and cook them for 3 minutes on each side. Remove and place on paper towels to drain. Serve with steamed rice and tempura dressing. (Serves 2-4)

INGREDIENTS

- 1 lb fresh colossal shrimp
- ¼ cup cornstarch
- ½ tsp salt
- 1 large egg
- 1 cup all-purpose flour
- ¼ cup panko breadcrumbs
- 1 tbsp coconut aminos
- 2 cups vegetable oil for frying
- 2 cups steamed white rice
- Tempura dressing (page 151)

 Active: 30 minutes Easy

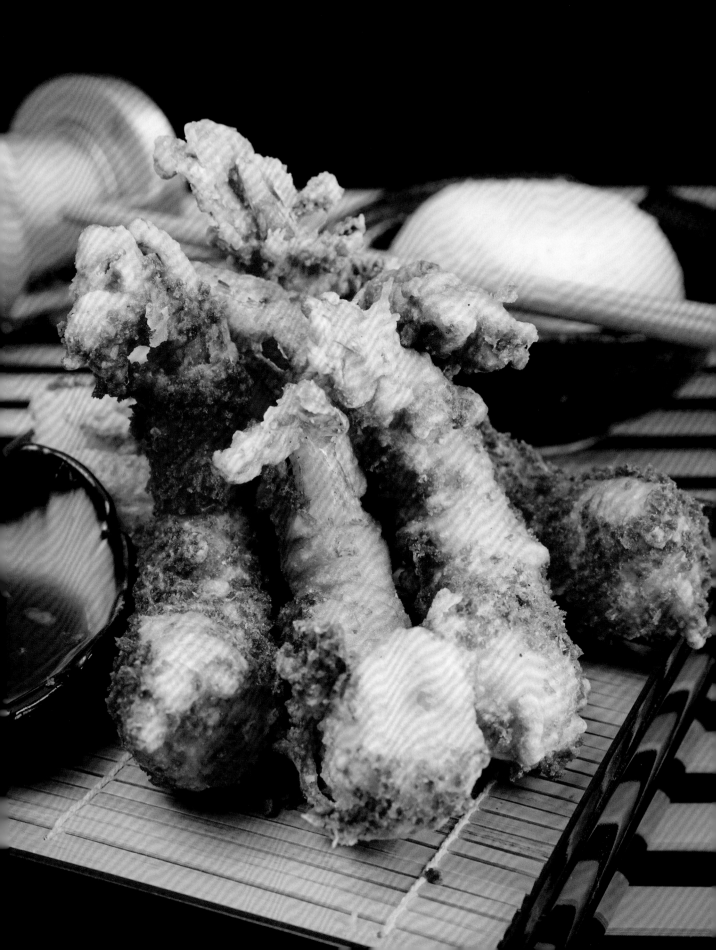

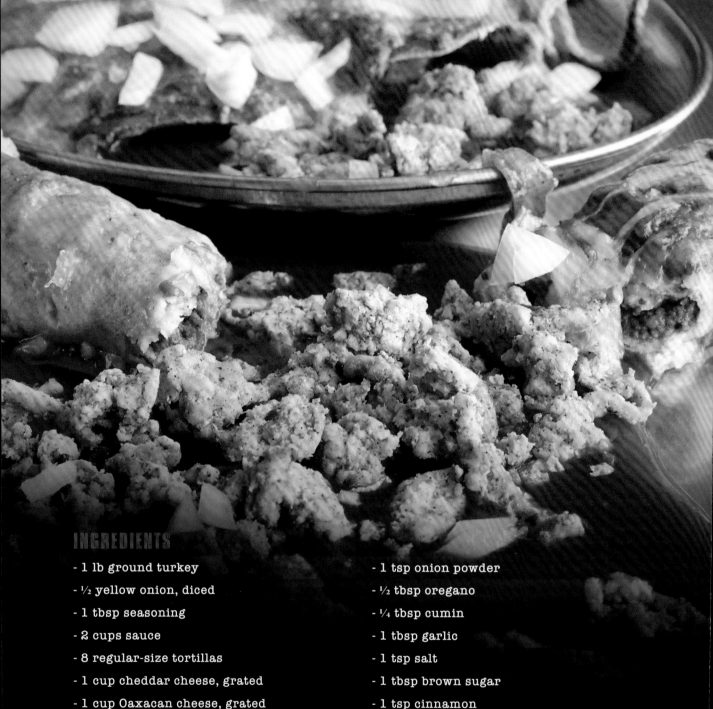

INGREDIENTS

- 1 lb ground turkey
- ½ yellow onion, diced
- 1 tbsp seasoning
- 2 cups sauce
- 8 regular-size tortillas
- 1 cup cheddar cheese, grated
- 1 cup Oaxacan cheese, grated
- 3 tbsp corn oil
- ¼ cup white onion, chopped
- 1 tbsp cilantro, chopped

Seasoning:

- 1 tsp chipotle powder
- 1 tsp Guajillo chili powder
- 1 tsp smoked paprika

- 1 tsp onion powder
- ½ tbsp oregano
- ¼ tbsp cumin
- 1 tbsp garlic
- 1 tsp salt
- 1 tbsp brown sugar
- 1 tsp cinnamon

Sauce:

- 3 tbsp corn oil
- 3 tbsp flour
- 2 tbsp seasoning blend
- 2 tbsp tomato paste
- 2 cups chicken broth
- 1 tsp apple cider vinegar

赤砂のエンチラーダ
RED SAND ENCHILADAS

Red sand left behind at Goro's lab gives inspiration to this dish, which is guaranteed to give our heroes the energy needed to help Godzilla take on Megalon.

1. Combine all seasoning spices together and set aside. Add 2 tbsp corn oil to large skillet over medium-high heat. Brown ground turkey until meat is no longer pink. Remove browned turkey and set aside.

2. Add 1 tbsp corn oil to the pan, heat up, and add chopped onion. Cook until translucent. Add turkey back in pan, along with 1 tbsp seasoning mix. Cook for another 2 minutes and remove from heat.

Sauce:

1. In a small bowl, add the flour and seasoning blend. Heat corn oil in medium pot over medium-high heat. Add the flour spice mixture to the hot oil, stir for 1 minute, add in the tomato paste. Whisk in the chicken broth and bring to a boil, reduce heat, and simmer for 10 minutes. Remove from heat and stir in vinegar. Combine cheeses in a large bowl and set aside.

2. Preheat oven to 350°F. Grease a large baking dish. Pour half the sauce into the baking dish to cover the bottom. Warm tortillas between two damp paper towels in a microwave (enough to fold without breaking) for roughly 30 seconds. Lay tortillas on a dish, spoon ground turkey mixture in the middle, top with 2 tbsp of cheese mix.

3. Roll up tortillas and place, seams-side down, in the baking dish. Top enchiladas with remaining enchilada sauce and cheese. Bake for 20 minutes or until heated through and cheese has melted. Serve with chopped onions and cilantro. (Serves 4)

 Active: 1 hour Easy

GODZILLA SPINE

Iconic in every way, this pizza recipe pays homage to those famous and versatile dorsal fins.

1. In a large bowl, dissolve the yeast in ⅔ cup lukewarm water, set aside for 5 minutes. Whisk in olive oil.

2. In a separate medium bowl, mix together flour, baking powder, and salt. Add into the wet ingredients. Combine well to make slightly sticky dough. Continue to add flour and mix until dough is not sticky.

3. Fold out of bowl onto floured surface, and knead into smooth dough ball. For a large 18-in pizza, use the ball as is. For smaller pizzas, cut dough in half. Shape each piece into a round dough ball.

4. Add a piece of parchment to a cookie sheet, lightly dust with flour, and transfer dough balls onto parchment. Place in warm spot and let rise for 1 hour. Preheat the oven to 500°F with a pizza stone or steel on the bottom-third rack.

5. For the pesto sauce, add all ingredients (except the olive oil) to a blender or food processor and process until it's a smooth sauce, adding olive oil as needed. Roll the dough out on a floured surface into a thin round crust. Add the sauce, mushrooms, and cheeses.

6. Using a floured pizza peel, carefully slide pizza onto it and transfer to hot pizza steel. Bake for about 12 minutes, until the crust is brown and the toppings are heated through. Remove from the oven and serve. (Serves 4)

INGREDIENTS

Dough:
- 1 ½ tsp instant yeast
- 2 cups all-purpose flour (plus extra for kneading)
- ½ tsp salt
- 1 tsp baking powder
- 2 tbsp olive oil

Pesto:
- 2 cups basil leaves
- 1 chipotle pepper in adobo
- ½ cup olive oil
- 4 garlic cloves, peeled
- ¼ cup parmesan cheese
- ¼ cup pine nuts
- Salt and pepper to taste

Pizza:
- 1 cup pesto sauce
- ½ cup shiitake mushrooms, sliced
- 1 cup mozzarella cheese, shredded
- ¼ cup parmesan cheese, grated

Special equipment:
Pizza steel, Pizza stone, Pizza peel

 Active: 30 minutes Easy

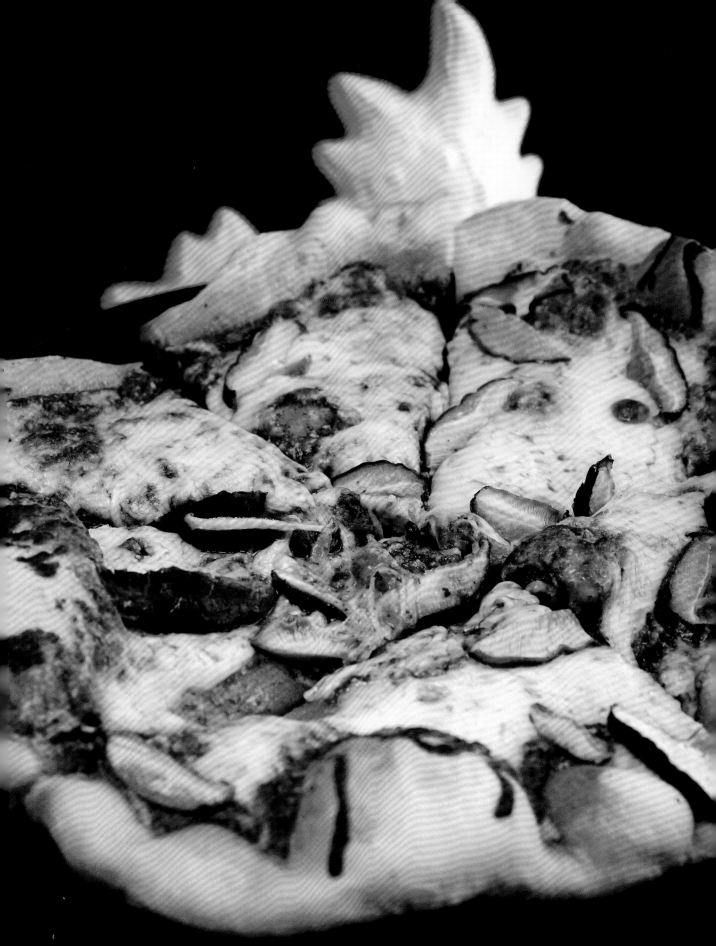

コズミックエッグサンド
COSMIC EGG SANDWICH

If there is one thing that seems to be in abundance in a world of kaiju it's eggs, so it seems appropriate to dine on a few.

1. Chop up hard-boiled eggs into small pieces and, with a fork, blend in mayo and Worcestershire sauce.
2. Add all the rest of the ingredients except salt, pepper, and bread, and combine until desired consistency. Add salt and pepper to taste. Serve on soft country-style bread with crusts cut off. (Serves 2)

INGREDIENTS

- 8 eggs, hard-boiled and cooled
- ½ cup mayonnaise
- 1 tsp Worcestershire sauce
- 1 tsp yellow mustard
- ½ tsp celery seed
- 1 tbsp chives, thinly sliced
- 2 tbsp celery, finely diced
- 2 tsp fresh dill, chopped
- Salt and pepper to taste
- Soft country-style bread

 Active: 10 minutes Easy

ミニラ巻き寿司

MINILLA SUSHI ROLL

Small in size but just as fearsome, Minilla enjoys its very own version of its father's classic izakaya favorite, with a little more color.

Sushi rice:

1. Add the rinsed rice, food coloring, and water to the rice cooker. Cook according to the instructions.
2. Transfer cooked rice to a very large bowl, allow to cool slightly, and mix in the rice vinegar, sugar, and salt.

Rolls:

1. Place plastic wrap on top of the bamboo mat. Place a nori seaweed sheet towards the bottom of the mat with the shiny side facing down. Using a flexible spatula, or, if using your hands, dip in warm water and evenly spread ¾ cup cooked rice on the nori, leaving a ½-in gap at the top. Add shrimp, purple sweet potato tempura, avocado, and cucumber slices on top of the rice.
2. Lift the bamboo roller up and over the filling, and roll the mat tightly away from you, pressing everything together until the ends meet. Remove from bamboo and place on cutting board. Dip your finger into warm water and moisten edge to seal. Cut down the middle, then down the middle of each piece, and once again to get 8 pieces. Top with wasabi tobiko, spicy mayo, and tenkasu. Serve with soy sauce and wasabi. (Serves 2-4)

INGREDIENTS

Rice:
- 1 cup sushi rice
- ¼ tsp orange food coloring
- ½ tbsp seasoned rice vinegar
- ½ tsp sugar
- ¼ tsp salt

Rolls:
- 6 shrimp tempura – follow Fisherman's Lunch recipe (see page 80)
- 1 purple sweet potato tempura – follow Fisherman's Lunch recipe
- ½ English cucumber cut into thin slices
- 1 avocado cut into thin slices
- 2 sheets nori seaweed
- Tenkasu
- Japanese spicy mayo
- Wasabi tobiko
- Soy sauce
- Wasabi

Special equipment:

Rice cooker, Sushi bamboo roller

 Active: 1.5 hours Intermediate

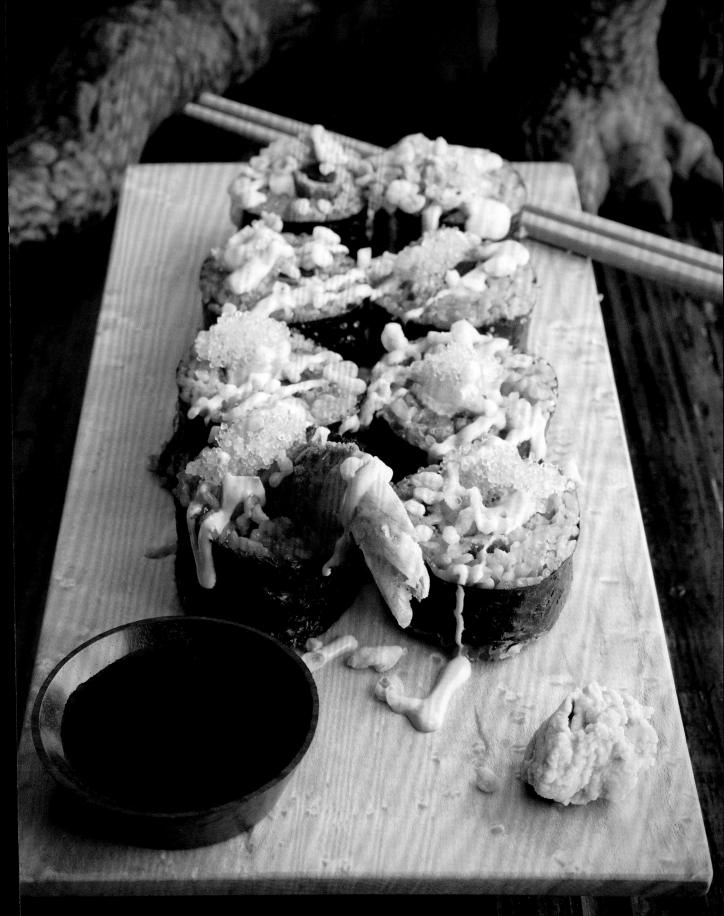

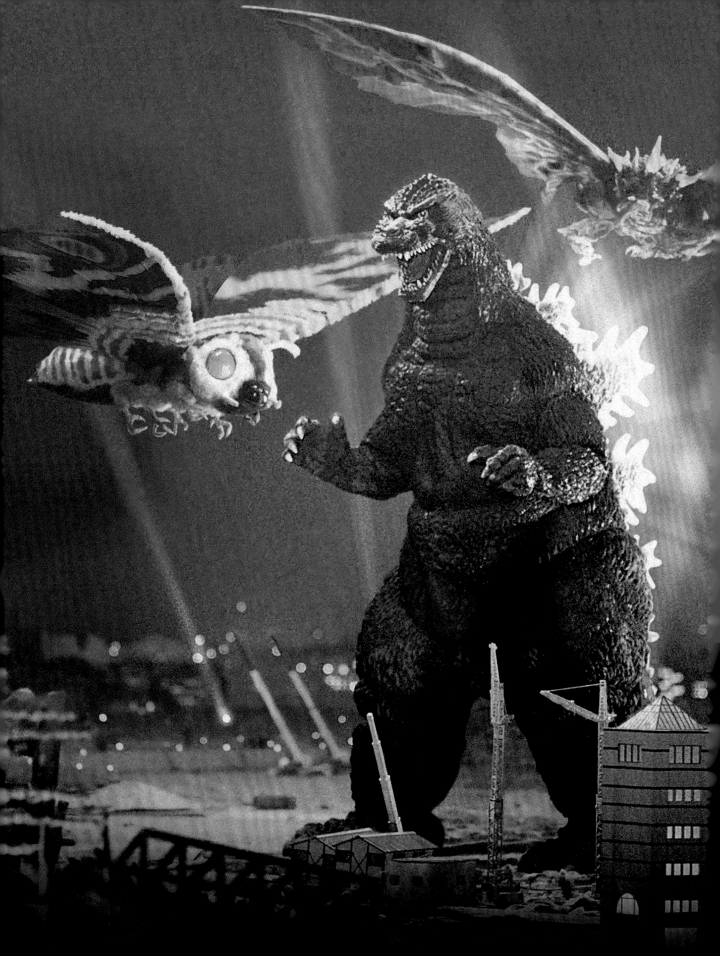

サイド

SIDES

On to the sides. All the sides are meant to compliment the main courses, but no one would tear down a city if any of these were served solo. The creamy and flavorful Mt Fuji Mash, reminiscent of the mighty mountain itself, is sure to satisfy, while the adorable Minilla Rings are perfect for dipping by fans of all ages. Surely no-one can resist diving into the King Ghidorah Dip, an homage to Monster Zero's three menacing, lightning-breathing heads, a touch of prophecy and intrigue await those who try the House of Azumi Prophecy Salad, while the hearty goodness of Anguirus Rice Balls could rival even the toughest of ankylosauruses. And when you're in need of a little comfort, the Odo Island Soup will warm your heart—just like the tales of the island's history.

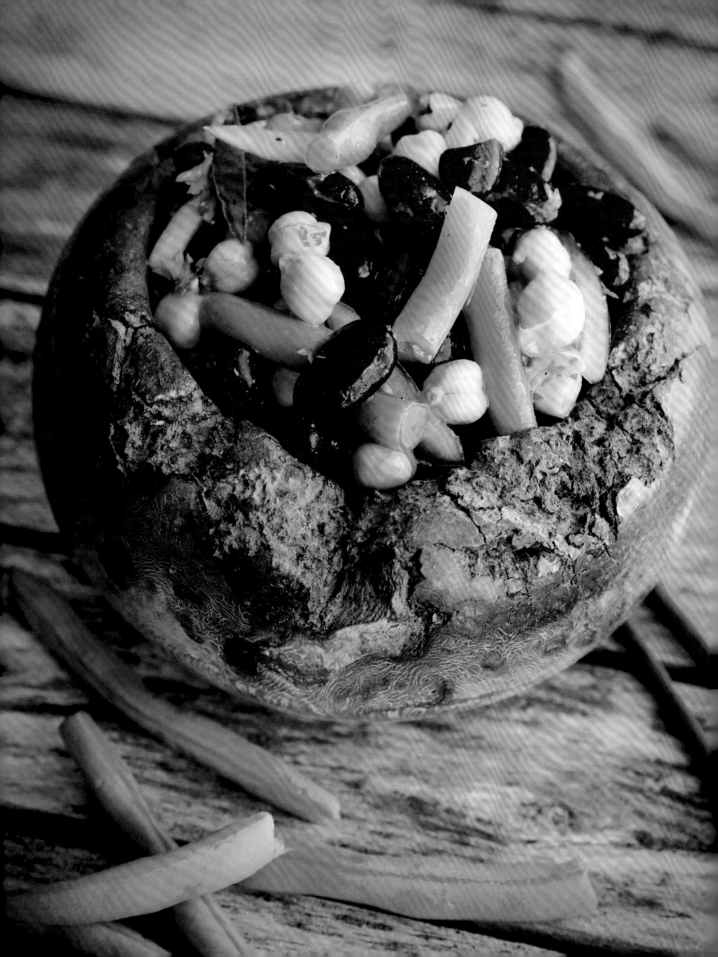

カントリーサイドサラダ
COUNTRYSIDE SALAD

Although Godzilla is known for terrorizing large cities such as Tokyo, it usually travels through the countryside to get there. The villagers therefore need a quick, tasty, and energizing meal to help them run as fast as they can!

1. Place a few cups of ice and cold water in a large bowl and set aside. In a medium saucepan, bring 4 cups salted water to a boil.
2. Cut green beans into thirds. Add green beans to boiling water and parboil for 3 minutes. Quickly remove with strainer, and place in cold-water bath to shock beans. Strain green beans through colander and add back to large bowl.
3. Add both cans of kidney and garbanzo beans to a colander, wash beans thoroughly, then add to the large bowl with the green beans. Add the red onion. Roughly chop the parsley, and add to the beans and onion.
4. In a small bowl, whisk the dressing ingredients, pour over bean mixture, toss to coat evenly. Refrigerate and marinate for at least 4 hours before serving. Serve with fresh ground pepper. (Serves 4)

INGREDIENTS

- 1 can kidney beans
- 1 can garbanzo beans
- 1 cup green beans, washed and trimmed
- ¼ cup red onion, sliced
- ¼ cup parsley

Dressing:
- 1 tbsp agave syrup
- ¼ cup rice vinegar
- ¼ cup olive oil
- ¼ tsp salt
- 2 tsp coconut aminos
- Fresh ground pepper

 Active: 30 minutes
Inactive: 4 hours Easy Vegan

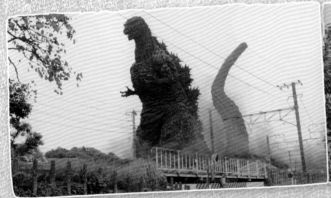

モンスター アイランド サラダ
MONSTER ISLAND SALAD

Potatoes are the highlight of this delicious side dish. Like its name suggests, it is made up of monster flavors, but be careful—its aroma may awaken some slumbering islanders.

1. Add potatoes to a medium saucepan with enough water to cover and 1 tsp salt. Bring to a boil over high heat. Reduce heat to medium and cook until the potatoes are tender (roughly 5-10 minutes).
2. Drain potatoes and add them to a large mixing bowl. Add vinegar and sugar, and very lightly toss together, trying not to mash the potatoes too much. Once coated, transfer to a baking sheet in a single layer to cool.
3. Cut cucumber and carrots into quarters, seed the cucumber, and proceed to thinly slice the cucumber and carrot. Transfer to the large mixing bowl and add ¼ tsp salt. Toss together and set aside.
4. Once the potatoes are cool, add them to the mixing bowl with the veggies and smash them together with the veggies, keeping some big potato chunks. Add sliced scallions, mayonnaise, coconut aminos, lemon zest and yuzu, and combine. Season with salt and pepper to taste. Refrigerate for 1 hour before serving. (Serves 4)

INGREDIENTS

- 1 lb russet potatoes, peeled and cut into large chunks
- 1 tbsp rice vinegar
- 1 tbsp coconut aminos
- 2 tsp sugar
- ½ an English cucumber, skinned
- 1 small carrot
- 2 spring onions, thinly sliced
- ¼ cup Japanese mayo
- 1 tsp grated lemon zest
- 1 tsp yuzu juice
- Fresh ground pepper
- 1 ¼ tsp salt, plus more to taste

 Active: 30-45 minutes
Inactive: 1 hour

 Easy

富士山マッシュ
MT FUJI MASH

This side dish, if constructed right, will majestically tower above all others.

1. Peel and chop potatoes into 2-in cubes. Add sweet potatoes to a large pot with salted water. Add the Japanese potatoes to a medium pan with salted water. Boil the potatoes for 20 minutes.
2. While potatoes cook, in a small pan, melt butter with sage on low heat and continue to slowly infuse butter with sage for 3-5 minutes. Remove from heat and remove sage pieces.
3. Drain potatoes. Using a potato ricer, press potato pieces through the ricer into a large bowl, add cheese and the sage butter, and mix (⅔ mixture to sweet potatoes, ⅓ mixture to Japanese sweet potato). You can add heavy cream if you prefer a different consistency. Check for seasoning and add salt. Serve side by side, or mixed together as a mountain. (Serves 6)

 Active: 45 minutes Easy Vegetarian

INGREDIENTS

- 3 lbs sweet potatoes
- 1 lb Japanese sweet potato
- 2 oz mascarpone cheese
- ¼ cup butter
- 5 sage leaves, cut into ribbons
- Salt to taste

難破パン
SHIPWRECKED BREAD

After being shipwrecked on Letchi Island in search of his missing brother, Ryota and his companions gained a real appreciation for bananas and oranges—after all, these fruits saved their lives.

1. Preheat oven to 325°F. In a stand mixer bowl, whisk together flour, baking powder, soda, and salt.

2. In a separate bowl, whisk sugar, eggs, and oil until light and fluffy. Mix in mashed bananas, orange juice, and zest. Transfer banana mixture to stand mixer bowl. With paddle attachment equipped, turn mixer on low to medium to mix ingredients well. Make sure to scrape sides and bottom of bowl.

3. Remove from mixer and fold in macadamias. Pour into greased 10 x 5in loaf pan. Bake for 30 minutes, then cover loosely with foil. Bake for an additional 25 minutes or until a toothpick inserted in the center comes out clean. Remove from oven, cool in pan for 10 minutes, then remove from pan and place on wire rack to cool completely. (Serves 8–12)

INGREDIENTS

- 3 cups all-purpose flour
- 1 cup coconut palm sugar
- 1 ½ tsp baking powder
- 1 ½ tsp baking soda
- ¼ tsp salt
- 1 tsp orange zest
- 3 tbsp coconut oil
- 2 large eggs
- 1 ½ cups ripe bananas, mashed
- ¾ cup tangerine juice
- ¾ cup chopped macadamia nuts

 Active: 1.5 hours Easy Vegetarian

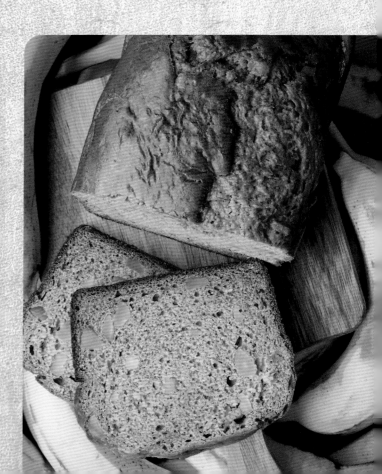

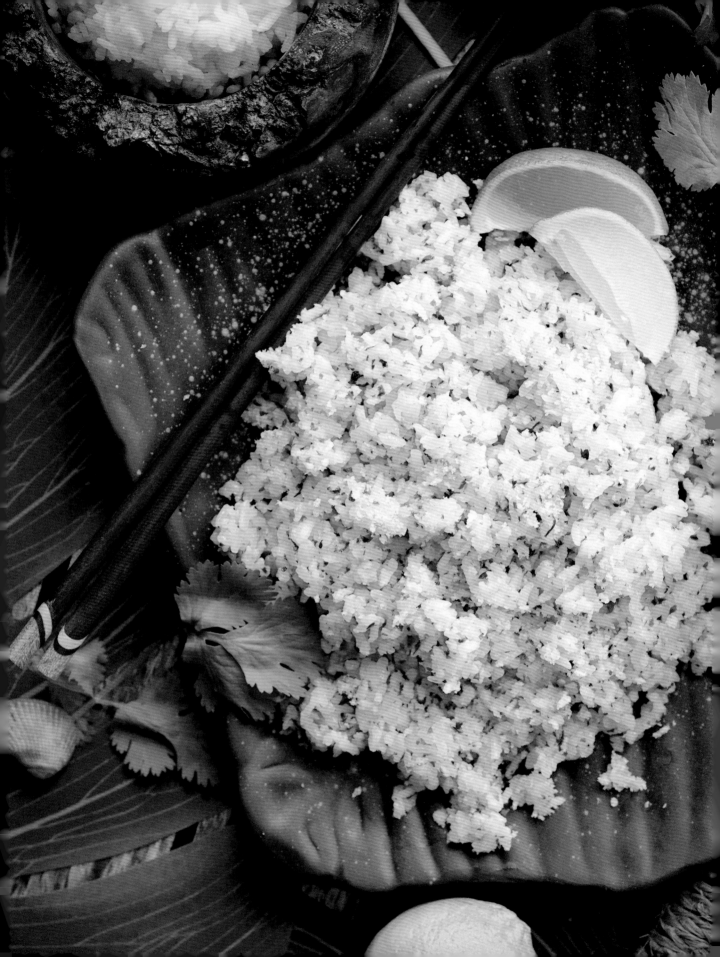

インファント島ごはん
INFANT ISLAND RICE

This dish harks back to the lush green paradise that is Mothra's home. Enjoy as a side or as a main course.

1. Add cilantro, parsley, onion, and garlic to a food processor, and process into paste. Heat coconut oil and butter in a wok. Add green herb blend to the oil, and heat for 1 minute. Add the rice, and fry for 5 minutes.
2. Add panko breadcrumbs to a dry pan and toast them lightly, remove and set aside. Transfer to a bowl, and top with panko crumbs and fresh lime juice. (Serves 4)

INGREDIENTS

- 2 cups cooked white rice
- ¼ cup cilantro, chopped (stems removed)
- ¼ cup parsley, chopped (stems removed)
- 1 large or 2 small garlic cloves, minced
- ½ small white onion, chopped
- ½ tsp salt
- 1 tbsp coconut oil
- 1 tbsp vegan butter
- 1 tbsp panko breadcrumbs
- Fresh lime
- Salt to taste

 Active: 30 minutes Easy Vegan

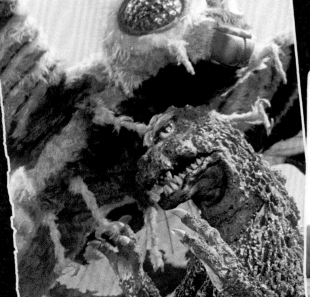

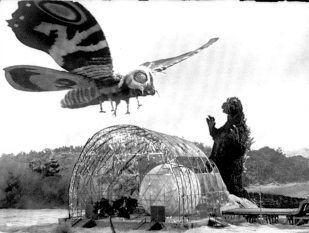

キングギドラ　ディップ
KING GHIDORAH DIP

King Ghidorah has landed and is ready to cause havoc! Help Godzilla out and keep this dangerous three-headed kaiju at bay by submerging it into a creamy dip.

1. Preheat oven to 350°F. Grease an 8 x 8in baking dish and set aside. In a large pot, add water and some salt and bring to a boil. In a large bowl, add ice water and set aside.

2. Trim the bottoms of the asparagus and then add asparagus to salted water, cook for 3 minutes. Remove with strainer and add to ice bath immediately and cool completely. Find the 3 spears that look the largest and the best, and set aside. Chop the rest of the asparagus and set aside.

3. In a large mixing bowl, add Mexican crema, Japanese mayo, cream cheese, garlic, and 1 cup Oaxacan cheese. Combine until smooth. Rinse artichokes under water, drain, and chop. Mix the artichokes and asparagus into cheese mixture, along with a touch of oregano to taste.

4. Pour mixture into a baking dish. Cover the dish with the rest of the cheese. Bake for around 20-25 minutes or until bubbly and slightly browned. Transfer to a serving bowl. Arrange the tops of the 3 asparagus spears into the shape of King Ghidorah heads. Place in dip and serve warm with bread. (Serves 4)

INGREDIENTS

- 1 bunch green or white asparagus
- 8-oz can artichoke hearts
- ½ cup Mexican crema
- ½ cup Japanese mayonnaise
- 8 oz cream cheese, softened
- 1 ¼ cups Oaxacan cheese, freshly grated
- 1 clove garlic, minced
- ¼ tsp dried oregano
- French bread slices

 Active: 1.25 hours Intermediate

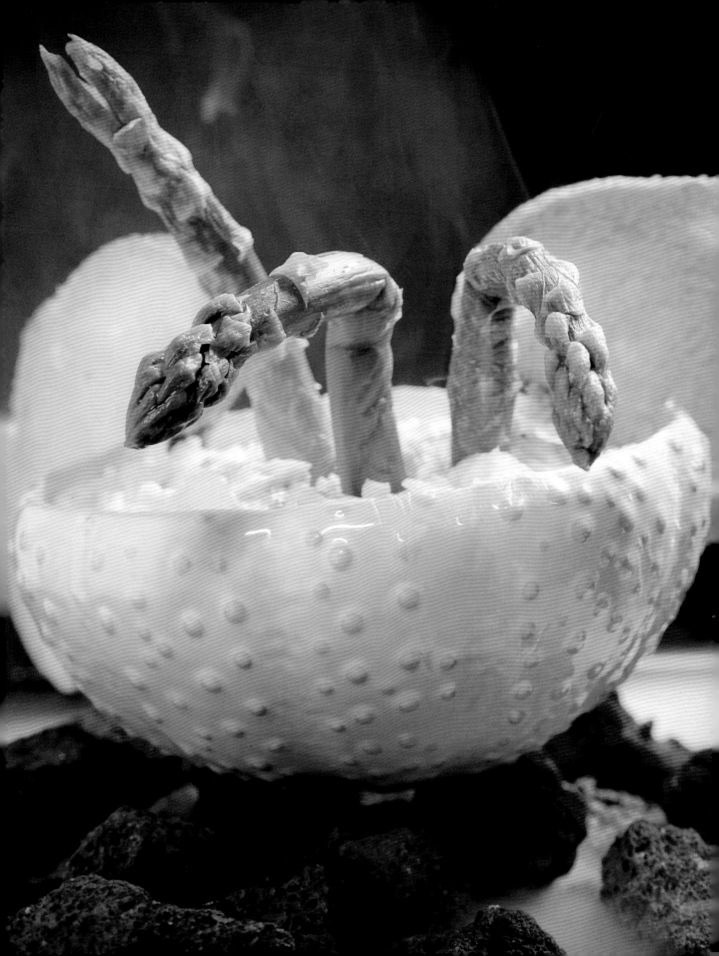

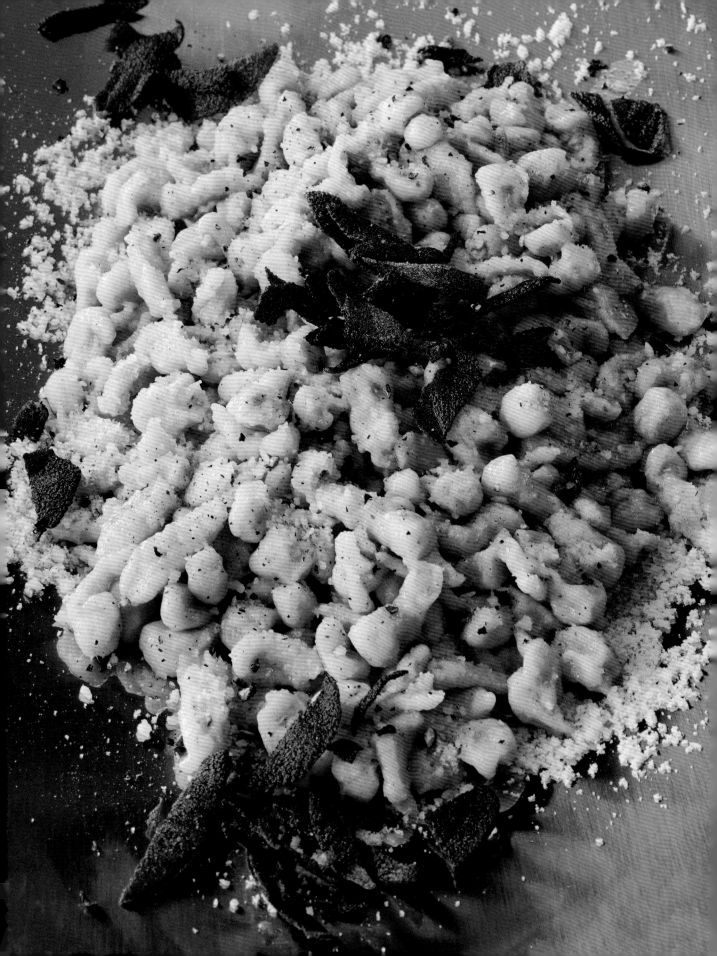

ガイガンのうろこ
GIGAN'S SCALES

Gigan's buzzsaw blades are dangerous in attack, but its armored scales make for a formidable defense.

1. In a small bowl, whisk together eggs and Worcestershire sauce and set aside. In a mixing stand bowl, whisk together flour, salt, and nutmeg. Add a well in the center of flour mixture, add egg mixture and, using a spatula, combine.

2. Place bowl in mixing stand and, using the paddle attachment on low, slowly add ½ cup water a little at a time until the dough is lump-free and has a smooth consistency. Do not add more water than needed; if you do, add more flour. Make sure you scrape the bottom of the bowl to incorporate all dry and wet ingredients.

3. Bring a large pot of salted water to a boil. Reduce heat to simmer. Place the spaetzle grater over the water and, using the spatula, fill up the grater and slowly grate the spaetzle pieces into the simmering water. They should 'drip' into the water slowly. Cook for roughly 3 minutes. The spaetzle pieces will float to the top when they are done. With a strainer, remove the spaetzle, drain, and place in large bowl. Repeat with the rest of the batter.

4. Take 6 sage leaves, remove stems, stack the halves together, roll them tightly from along the center vein, and then slice into fine strips.

5. In a very large frying pan over low-medium heat, add the butter and sesame oil, melt butter, add sage. Continue to slowly fry up the rest of the sage with the butter, making a brown sage sauce (roughly 5 minutes). Remove sage pieces and set aside.

6. Immediately add spaetzle to the pan, toss together with butter sage sauce, and lightly fry until some pieces have a crispy side. Serve with parmesan cheese, fresh ground pepper, and fried sage. (Serves 4)

INGREDIENTS

- 2 ¼ cups all-purpose flour
- 4 medium-sized eggs
- 1 tsp Worcestershire sauce
- ½ tsp fresh ground nutmeg
- ½ tsp salt
- 24 fresh sage leaves
- ½ cup vegan butter
- ½ tsp sesame oil
- Finishing salt
- Fresh ground pepper
- ½ cup parmesan cheese, grated
Special equipment: Spaetzle grater

 Active: 30-45 minutes Easy

アズミ族の予言サラダ

HOUSE OF AZUMI PROPHECY SALAD

This prophecy seemed too far-fetched to be taken seriously until strange happenings began on Okinawa. As the House of Azumi is protected by a slumbering Chimera, it is wise to watch for a red sun rising in the west.

1. Preheat oven to 425°F. Wash beets and trim ends only. Add to a large baking dish, pierce skins with knife, add 2 cups water to the bottom, and sprinkle salt on top of beets. Cover dish with foil and place in oven to roast for 50 minutes.

2. Remove from oven and let sit to cool for 2 hours, or until you can handle the beets with your hands. Using gloves, remove skins and discard. Golden beets should have a gradient. Slice beets thinly top to bottom. Layer golden beets in a shallow dish and red beets in a separate bowl. Mix vinaigrette dressing and add half or up to two thirds of mixture to the beets to marinade. Cover, place in refrigerator, and marinate for 2 or more hours.

3. Remove from refrigerator, add greens and walnuts onto a plate or bowl. Layer the beets as if the sun and its rays were rising from the west. Finish with more dressing, flaky salt and ground pepper, and goat cheese if desired. (Serves 2)

INGREDIENTS

Beets:

- 2 large red beets
- 4 small to medium golden beets
- 2 cups greens of choice
- Halved walnuts
- Goat cheese (optional)
- Flaky salt
- Fresh ground pepper

Vinaigrette:

- 1 tsp coconut aminos
- 1 cup rice wine vinegar
- ¼ cup olive oil
- 2 tsp agave syrup
- ½ tsp salt
- ⅛ tsp celery salt
- ¼ tsp garlic powder
- ¼ tsp onion powder
- 2 tsp white balsamic vinegar
- Fresh ground pepper

 Active: 1.5 hours
Inactive: 2 hours Easy Vegan

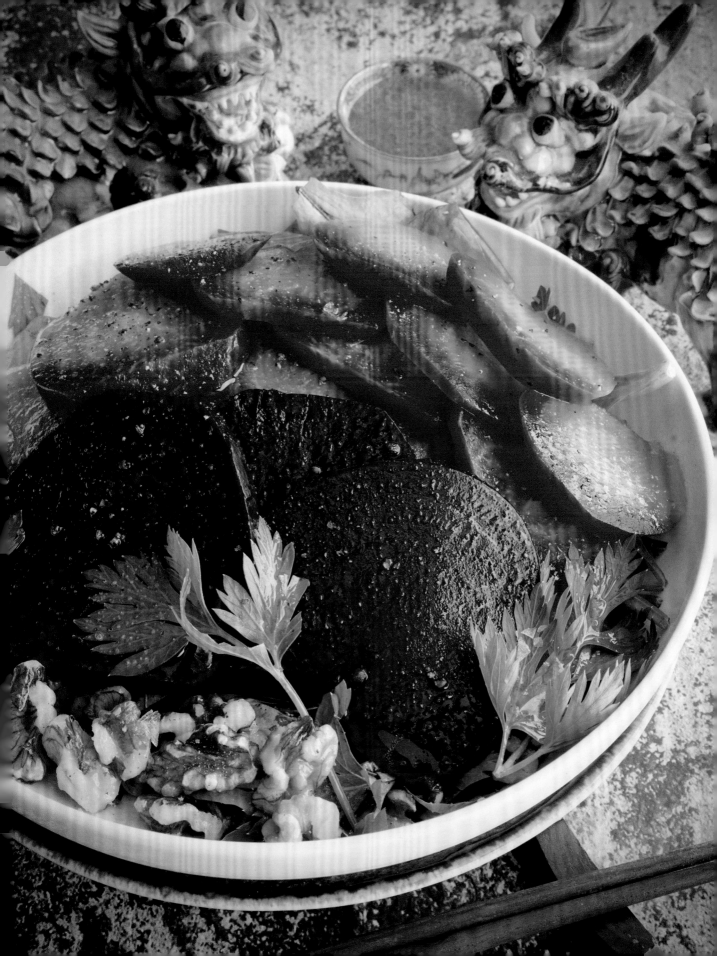

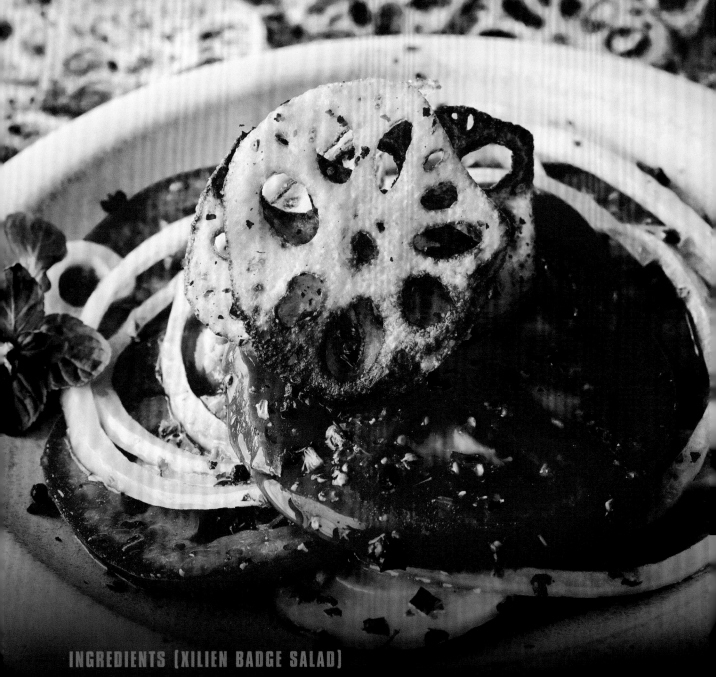

INGREDIENTS (XILIEN BADGE SALAD)

- 2 large heirloom tomatoes, sliced
- ½ sweet onion, sliced
- 1 tsp fresh oregano, chopped
- 1 tsp chives, chopped
- ½ cup rice wine vinegar
- 2 tbsp balsamic vinegar
- 1 tbsp agave syrup
- 1 tbsp olive oil
- Salt and fresh ground pepper to taste

INGREDIENTS (SATELLITE DISHES)

- 1 lotus root
- 1 tsp rice vinegar
- 2 cups vegetable oil
- Black salt
- Pink peppercorns

X星人バッジサラダ
XILIEN BADGE SALAD

Whether you are the Controller or just another Xilien looking forward to world domination, that red badge is the perfect complement to your monochromatic ensemble.

1. In a small bowl, whisk together vinegar, agave syrup, herbs, and olive oil.
2. In a medium shallow bowl, layer sliced tomatoes and onion, season with salt and pepper. Cover tomatoes and onions with the dressing, cover with plastic wrap and marinate in refrigerator

for at least an hour. Serve with fresh herbs and ground pepper. Serve with Satellite Dishes (see below). (Serves 4)

 Active: 20 minutes Inactive: 1 hour Easy Vegan

衛星アンテナ
SATELLITE DISHES

These crunchy snacks won't help you communicate with alien beings from outer space, but they will make a sound that can be heard around the table.

1. Prepare a large baking sheet with paper towels and a wire rack, and set aside. Peel and slice lotus root; using a mandolin, slice as thin as possible (⅛-in thick is best).
2. In a measuring cup, mix water and vinegar together. Add water mixture to a shallow baking dish, place the lotus root slices in the water, and soak for 15 minutes.
3. In a large frying pan, heat up the oil to 350°F. Remove lotus slices from water and place on

paper towels. Pat them as dry as possible. Add them to the oil and fry until golden brown (roughly 2-3 minutes).
4. Using a spider strainer, remove from oil and place on wire rack to drain. Serve with Xilien Badges and top off with salt and freshly ground pink peppercorns. (Serves 4)

 Active: 30 minutes Easy Vegan

アンギラスおにぎり
ANGUIRUS RICE BALLS

As one of Godzilla's closest friends in battle, this massive ankylosaurus kaiju needs a dish reminiscent of its formidable attack ball. These flavor-packed rice balls roll up to the challenge.

1. Using a rice cooker, add the rice, water, ½ tsp salt, and the 2 packets of annatto powder, stir and cook as normal. While rice is cooking, take the onion, garlic, and ginger, and chop in a food processor until a paste is formed. Set aside.

2. Add 1 tbsp sesame oil to a hot wok. When oil is shimmering, add ground beef, season with ¼ tsp salt, cook until browned, and then remove and discard any liquid. Heat 1 tbsp sesame oil in wok, add onion paste and cook for 2 minutes. Add soy sauce, mirin, and agave syrup, stir to combine well. Add the beef back into the wok and mix.

3. Remove from heat and set aside to cool until rice is ready. Rice should be warm or cool, but not hot or cold. Add 1 tsp salt to ¼ cup water in a small bowl. Moisten your hands with the salt water. Place half a cup of rice in your hand. Using a small melon scoop (roughly 1 tbsp), make an indentation in the rice and add 2 scoops of beef. With your other hand, cover the beef with more rice and make a ball. Roll the ball in black sesame seeds. Serve warm. Can be refrigerated and then microwaved for 1-2 minutes. (Serves 4-6)

INGREDIENTS

- 3 cups white short grain rice
- 2 packets of coriander & annatto seasoning
- ¼ lb ground beef
- ¼ cup sweet onion
- 1 garlic clove
- ½ inch fresh ginger, peeled and sliced
- 2 tsp dark soy sauce
- 2 tsp mirin
- 2 tsp agave syrup
- ½ cup black sesame seeds
- 2 tbsp sesame oil
- 1 ¾ tsp salt

 Active: 1 hour
Rice: 45-60 minutes

 Easy

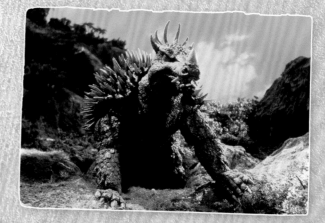

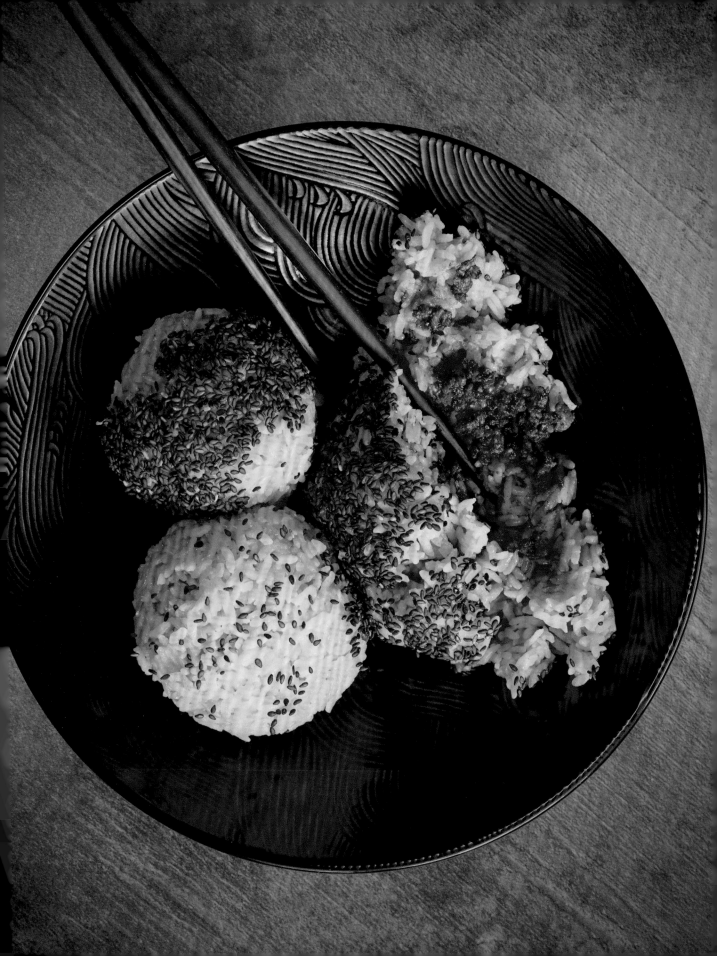

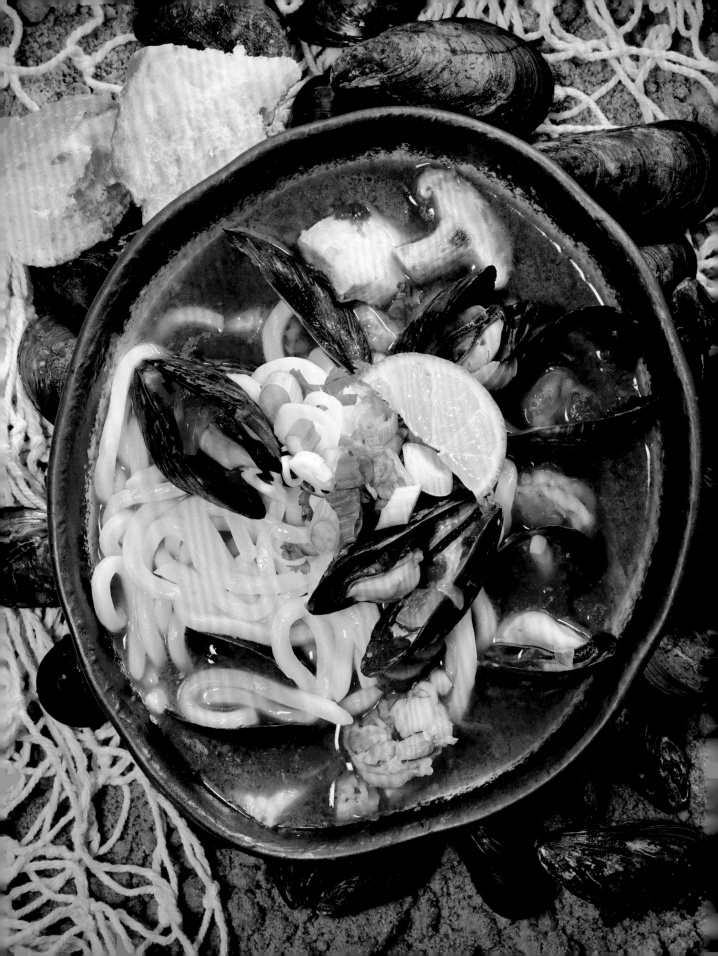

大戸島スープ
ODO ISLAND SOUP

With the fishing village in ruins on this once tranquil island, we were lucky to have been able to find and recreate their signature fish soup.

1. Bring 8 cups water to a boil and add the Hondashi. Remove from heat and stir to make broth. Set aside.

2. In a small bowl, add ¼ cup boiling water along with Japanese chilies, allow to sit until rehydrated. Add the chilies and ¼ cup water to a processor, along with 4 cloves of garlic, 1 tbsp chopped cilantro, and 1 tbsp ginger. Process until smooth.

3. In a large Dutch oven, add oil and heat over medium-high heat. Add onion, a pinch of salt and sauté until browned (roughly 3–5 minutes). Add soy sauce and chili mix, sauté for 1 minute.

4. Add broth, bring to a boil, reduce the heat to low, cover, and simmer for 15 minutes. Add tomatoes and mussels, stir and cover, then cook for 5 minutes until all shells open. Discard unopened mussels. Remove open mussels from soup and place on plate. Add shrimp and tilapia, return to boil over medium heat.

5. Reduce the heat to low, cover, and simmer for 5 minutes or until fish is cooked through and flaky. Stir in the sliced mushrooms, cover, and let sit for 5 minutes. Cook Udon noodles as recommended, place in serving bowls, add cooked mussels in serving bowls, and ladle fish soup into bowls. Serve with chopped cilantro, scallions, lime wedges, and bread. (Serves 2-4)

INGREDIENTS

- 2 dried Japanese chilies, seeded and de-veined
- 4 garlic cloves
- 1 medium yellow onion, chopped
- 8 tsp Hondashi powder
- 8 cups water
- 1 tbsp fresh ginger, sliced
- 1 tbsp dark soy sauce
- 1 15-oz can peeled and diced tomatoes
- 12 jumbo shrimp, peeled and de-veined
- ½ lb tilapia fillets, cut into chunks
- 12 mussels
- 2 tbsp vegetable oil
- 2 scallions, sliced
- 2 tbsp cilantro, chopped
- 5 small shiitake mushrooms, sliced
- 4 Udon noodle packets
- 1 lime, cut into wedges
- Crunchy bread

 Active: 1 hour Easy

ゴジラの尻尾
GODZILLA TAILS

Godzilla's titanic tail often does just as much damage to the Tokyo skyline as its dreaded heat ray. Or maybe it's just playfully wagging its tail?

1. The melons can be very bitter, but this pickling process can help make this healthy side dish tastier. Wash melons thoroughly, slice in half lengthwise, and remove seeds. Cut them into ¼-in slices and set aside.

2. Bring a pot of water to boil and at the same time prepare a large bowl with ice water. Once water is boiling, add the melon to the water and boil for 90 seconds. Quickly remove pot from heat and drain melon through colander. Add drained melon slices to the ice bath to stop the cooking. Let them sit for a few minutes until cool. Drain again in colander.

3. In the large bowl, whisk together vinegar, sugar, coconut aminos, mirin, lemon juice, ginger, salt, and pepper, then add sliced onions, parsley, and melon slices. Toss together to coat completely. Cover with plastic wrap and let marinate in refrigerator for at least 4 hours (though preferably overnight). To serve, arrange on a flat plate in descending order as the Godzilla tails they are. Top with fresh ground pepper and parsley. (Serves 4–6)

INGREDIENTS
- 3 bitter melons
- 1 cup white onion, sliced
- ¼ cup fresh parsley, chopped
- ¼ cup seasoned rice wine vinegar
- 1 tbsp sugar
- 2 tbsp mirin
- 1 tbsp lemon juice
- 1 tbsp coconut aminos
- 1 tsp ginger, minced
- Fresh ground pepper
- ½ tsp salt
- Water and ice

 Active: 30 minutes
Inactive: 4-24 hours Easy Vegan

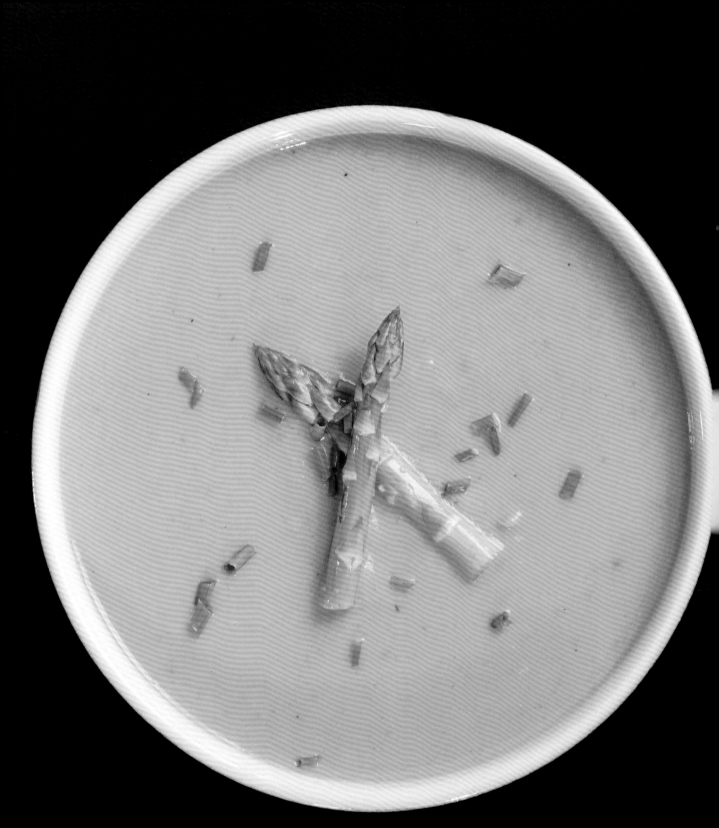

メガロンのスープ
MEGALON SOUP

Haven't seen Megalon in a while? Well, that may be because when Megalon isn't defending Seatopia from another surface-created catastrophe or being controlled by an alien species it stays submerged under the planet's surface, its powerful drill arms ready to help burst through the Earth's crust!

1. Heat butter and oil in a large Dutch oven over medium heat. Add garlic and cook for 30 seconds. Add asparagus and sauté until cooked through (about 6 minutes). Add broth, bring to a boil, reduce heat to a simmer and cover, simmer until asparagus is tender (10-15 minutes).

2. Remove from heat and puree using a blender or immersion blender. Always be careful if blending hot liquid. Return soup to pot and, over low heat, stir in coconut cream, lemon juice, and salt. Cook for another 3 minutes.

3. Take off heat and finish seasoning with salt and pepper to taste. Serve hot with chopped chives, lemon wedges, and crunchy bread. (Serves 4)

 Active: 1 hour Easy 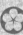 Vegan

INGREDIENTS

- 3 bunches asparagus, trimmed and cut into pieces
- 1 tbsp vegan butter
- 1 tbsp olive oil
- 2 cloves garlic, minced
- 2 tbsp lemon juice
- 3 cups vegetable broth
- ½ cup coconut cream
- 1 tbsp chives, chopped
- ½ tsp Kosher salt
- Freshly ground black pepper
- Crunchy bread
- 1 lemon

ミニラリング

MINILLA RINGS

The adopted child of Godzilla has its parent's heat ray, it just hasn't refined its use yet—until you step on its tail. For now, these rings are just the cutest.

1. Prepare a large baking sheet with paper towels and a wire rack and set aside. In a medium bowl, whisk together the buttermilk and egg. In a separate medium bowl, whisk together flour, Mochiko flour, salt, pepper flakes, and garlic powder. Lastly, add panko breadcrumbs to a dish.

2. Dip the onion rings in buttermilk mixture, then flour, then back in the buttermilk mixture, and then the panko. Place each coated onion on one half of the baking sheet to sit for at least 15 minutes (more is ok).

3. Using a cast iron skillet, add the oil and heat it to 350°F. Making sure not to overcrowd the pan, add 2–4 rings at a time and cook them until golden brown (3 minutes on each side). Transfer fried onion rings to a wire rack set over the other half of the baking sheet. Continue until all onion rings are fried. Serve with aioli. (Serves 2–4)

Blue Aioli:
Whisk all ingredients together, and season with salt to taste.

INGREDIENTS

- 1 large sweet onion, sliced into ½-inch-thick rings
- 1 cup buttermilk
- 1 large egg
- ½ cup all-purpose flour
- 2 tsp Mochiko rice flour
- 1 tsp salt
- ½ tsp pepper flakes
- ½ tsp garlic powder
- 1 cup panko breadcrumbs
- 2 cups vegetable oil for frying

Blue aioli:
- ½ cup Japanese mayo
- 1 tbsp lemon juice
- 2 cloves garlic, minced
- 10 drops blue food coloring

 Active: 40 minutes Easy

デザート

DESSERTS

Welcome to the sweetest showdown this side of Tokyo! In the desserts section we're unleashing a sugary rampage that'll leave your tastebuds roaring for more. Brace yourselves for the almondy delights of Rodan Beaks, satisfy your sweet tooth with monochromatic Xilien Cookies—mysterious and out of this world—and don't miss the Red Bamboo Cake. If coconut is your weakness, then look no further than the kaiju King Caesar itself—its namesake cookies are fit for royalty. And if you are in a hurry to evacuate the area due to the GPN's warning, Jet Jaguar Mugcakes are quick to make.

アイランド　ラブル
ISLAND RUBBLE

Destruction is a kaiju's calling. Sometimes ice cream can just make that undeniable fact a little bit easier to deal with.

1. Preheat oven to 350°F. Spray an 8-inch-square baking dish with cooking spray and set aside. In a large bowl, add gooseberries, currants, sugar, lemon zest, yuzu, and cornstarch. Stir to combine. Pour into prepared baking dish.

2. In a medium bowl, mix the flour, oats, coconut palm sugar, cinnamon, nutmeg, and salt together. Using pastry or cooking gloves, add cold butter cubes to the flour mixture and combine until you are left with crumble. Cover the berries with the crumble mixture. Bake for 50–55 minutes until the top is crispy and the berries are bubbling. (Serves 4)

INGREDIENTS

- Cooking spray
- 3 cups green gooseberries, cleaned and de-stemmed
- 1 cup white currants
- 1 cup red currants
- 1 + ⅓ cup sugar
- 1 ½ tsp lemon zest
- 1 tbsp yuzu juice
- 2 tbsp cornstarch

Crumble Topping:
- 1 cup all-purpose flour
- ½ cup rolled oats
- ½ cup coconut palm sugar
- ¼ tsp ground cinnamon
- ¼ tsp ground nutmeg
- Pinch salt
- ½ cup cold unsalted butter, cubed

 Active: 2 hours Easy Vegetarian

ロダン ビーク
RODAN BEAKS

Rodan's beak is notoriously powerful, but these beaks speak to the sweeter side of Rodan. Pack them up on a picnic to Monster Island—just try not to wake it while you're there.

1. In a medium bowl, sift together the all-purpose flour and the baking soda and set aside. In a stand mixer with a paddle attachment, beat together the almond flour, coconut flour, salt, and butter until light and fluffy but still gritty to the touch (about 4 minutes). Scrape sides and bottom often. Mix in one egg and almond extract until combined. On low speed, add in sugar until combined. Slowly add in the sifted flour mixture and process until dough forms.

2. Roll out dough mixture on a floured surface, knead slightly into dough ball, wrap in plastic, and refrigerate for up to 3 hours.

3. Pre-heat oven to 350°F. Grease cookie sheet with cooking spray and set aside. Remove dough from refrigerator and, using an Asian soup spoon, scoop out and form 'beak'-shaped cookies and place them on the greased cookie sheet. Press almonds on top of the cookies.

4. In a small bowl, whisk one egg and, using a brush, paint the whisked egg over the cookies. Bake cookies for 15 minutes, or until crisp and golden on the edges. Remove cookies and let them cool on a wire rack for at least 10 minutes. (Makes 24 cookies)

 Active: 45 minutes
Inactive: 3 hours Easy Vegetarian

INGREDIENTS

- 1 cup almond flour
- ⅓ cup coconut flour
- 1 cup unsalted vegan butter
- Pinch salt
- 2 large eggs
- 1 tsp almond extract
- 1 ¾ cups all-purpose flour
- 1 cup sugar
- ½ tsp baking soda
- Sea-salted Marcona almonds

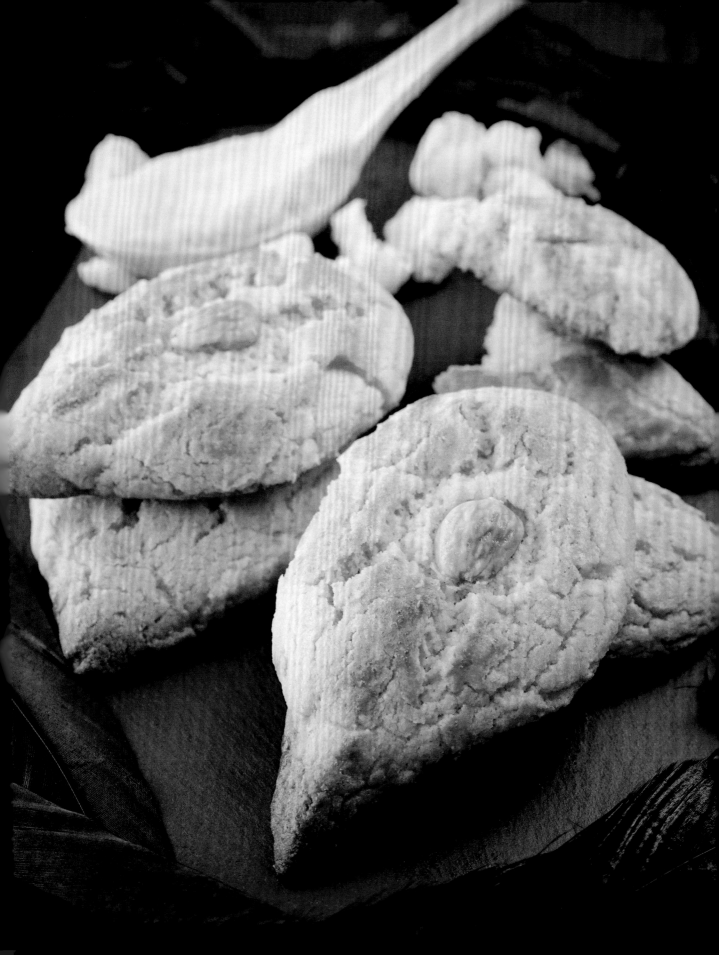

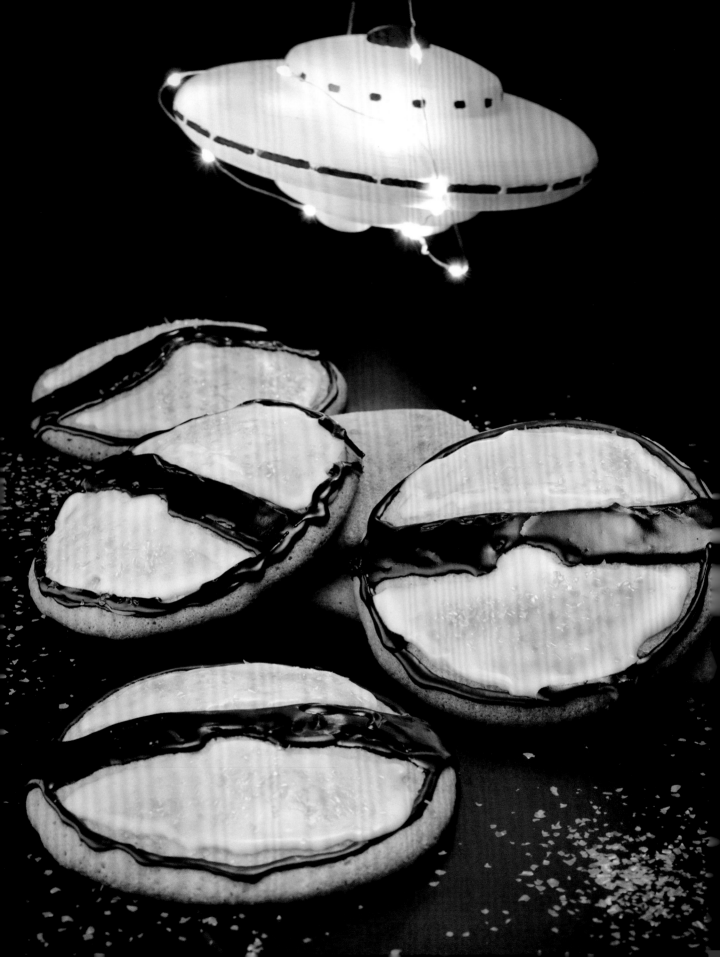

X星人クッキー
XILIEN COOKIES

These delicious cookies are inspired by the color palette (or perhaps lack-of-color palette) of the Xiliens.

1. Preheat oven to 350°F. In a large bowl, whisk the flour, baking powder, and baking soda, and set aside. In a stand mixer bowl fitted with a paddle attachment, cream together the sugar, butter, and coconut extract, making sure to stop and scrape all sides and bottom of the bowl to incorporate everything. Add the egg and continue to beat on medium until mixture is fluffy.

2. Remove bowl and fold in the sour cream until well combined but still light and fluffy. Place bowl back on mixer and set it to low. Add the flour mixture in 3 batches. Scrape all sides, and make sure all ingredients are well combined.

3. Prepare 2 cookie sheets with cooking spray or parchment paper. Place 12 ¼-cup dollops of cookie batter roughly 3–4 in apart on the sheets. Bake for 13–15 minutes (times will vary, look for the edges to brown). Remove from oven and allow to cool on wire rack until fully cooled.

4. For the icing, in a large bowl, whisk the confectioners' sugar, 5 tbsp milk (adjust as needed to get the right consistency), agave syrup, coconut extract, and salt together. Transfer 2 cups of icing to a small bowl and add Dutch chocolate cocoa powder, along with 1 tbsp coconut milk. Whisk until combined.

5. Pipe chocolate icing onto the edge of the cookies and create the Xilien sunglasses on the upper third of the cookie. Refrigerate for 20 minutes until fully set. With a spoon, carefully fill the rest of the cookie with coconut icing and let set completely before serving. (Makes 12 cookies)

 Active: 2 hours Intermediate Vegetarian

INGREDIENTS

- 1 ¾ cups flour
- ½ tsp baking powder
- ½ tsp baking soda
- 6-12 tbsp vegan butter
- 1 cup sugar
- 1 large egg
- 2 tsp coconut extract
- ½ cup lactose-free sour cream

Icing:

- 5 ½ cups confectioners' sugar
- 12 tbsp coconut milk
- 1 tbsp agave syrup
- 1 tsp coconut extract
- ½ tsp salt
- 4 tbsp Dutch-process cocoa powder

赤イ竹餅
RED BAMBOO CAKE

Letchi Island is home to this army, whose sole purpose seems to be to make a fruit extract to fend off a deep-sea kaiju. This spectacular cake is a much better use of those bananas than whatever that yellow stuff is...

1. Preheat oven to 325°F. Prepare 2 8-in cake pans with cooking spray and flour. Set a stand mixer up with a paddle attachment on medium speed and cream the butter with the sugars until fluffy (roughly 5-7 minutes). Add in vanilla and one egg at a time until all eggs are mixed in and fluffy again.

2. Add the bananas to a medium bowl, mash them together with the lemon juice, and set aside. Whisk together the flour, baking soda, and salt in a medium bowl. With the stand mixer set on low-medium, add a third of the flour mixture and a third of the milk at a time. Mix until combined but not overmixed.

3. Remove bowl from mixer stand and fold in the bananas. Pour into prepared pans. Bake cakes for 45-55 minutes, or until inserted toothpick comes out clean. Place cakes in refrigerator to cool.

4. To make the frosting, cream together butter and cream cheese until fluffy (about 3-5 minutes). Add in lemon juice, zest, and orange extract. Mix in confectioners' sugar one third at a time, and finish with red food coloring.

5. Remove cakes from refrigerator, place one cake on cake plate, and cover top with frosting. Place the second layer on top and cover entire cake with frosting. Slice the slightly ripe banana and top the cake with the slices. (Serves 8)

INGREDIENTS

- Cooking spray
- 3 cups flour (plus extra for dusting)
- ½ cup coconut palm sugar
- 1 cup white sugar
- 1 ½ cups almond milk
- 3 tbsp lemon juice
- 3 very ripe bananas
- ⅔ cup vegan butter, softened
- 3 large eggs
- 1 tsp vanilla extract
- 1 ½ tsp baking soda
- ¼ tsp kosher salt

Frosting:
- 8 oz cream cheese
- ⅓ cup butter, softened
- 2 tsp lemon juice
- 2 tsp lemon zest
- 1 tsp orange extract
- 4 cups confectioners' sugar
- 1 tsp deep red food coloring
- 1 slightly ripe banana

 Active: 2 hours Intermediate Vegetarian

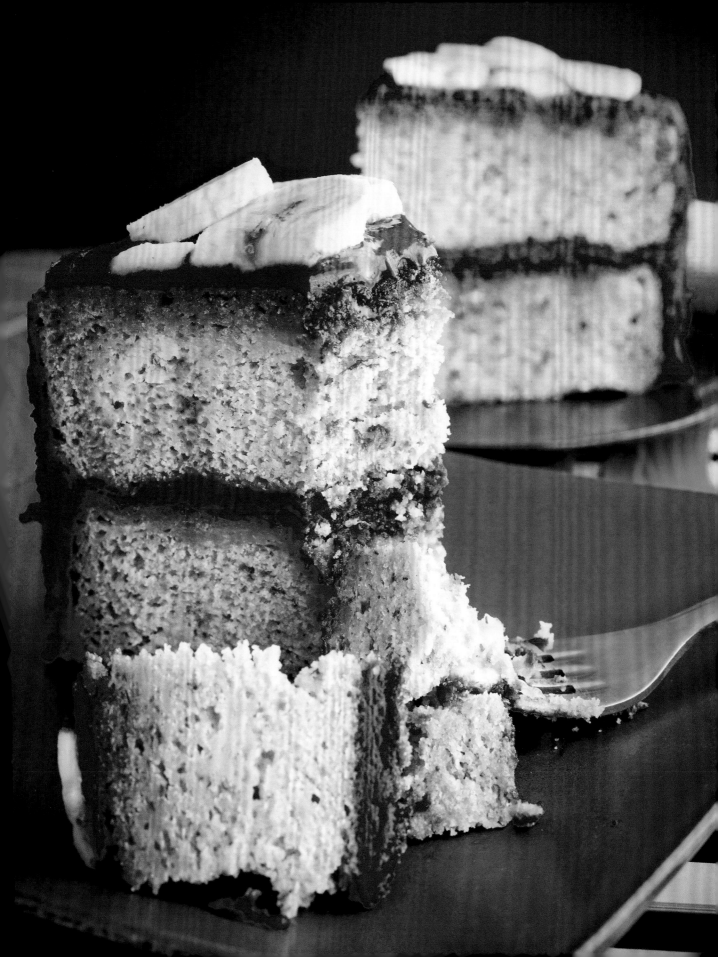

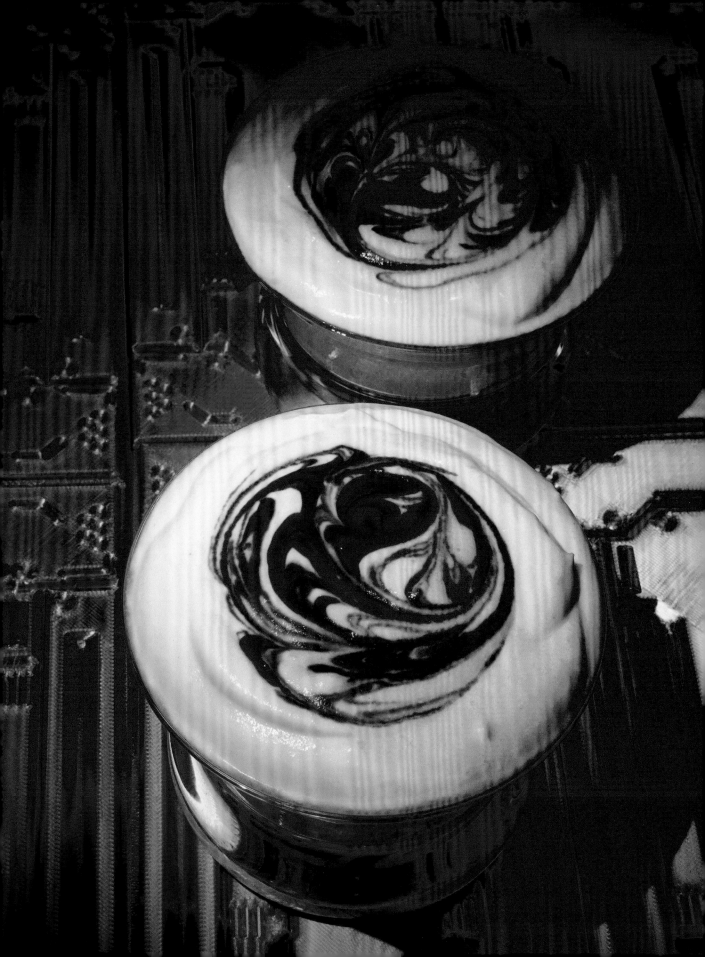

M宇宙ハンター星雲ムース

M SPACE HUNTER NEBULA MOUSSE

Even insect creatures can't resist a little taste of home—or at least a nebula-styled dessert.

1. In a large bowl, using a hand mixer, mix coconut cream, yuzu juice, yogurt, lemon zest, and the pinch of turmeric for color. Set aside.

2. In another large bowl, using a whisk attachment on the hand mixer, whip together heavy cream and powdered sugar until stiff peaks are reached. Using a spatula, fold the whipped cream into the lemon coconut cream mixture carefully until fully incorporated.

3. Transfer to serving glasses, add 1 drop red and blue food coloring to the center of the mousse and, using a chopstick, swirl the two together to create the nebula. Refrigerate for at least 3 hours before serving. Top with lemon zest.

INGREDIENTS

- 2 tbsp yuzu juice
- ½ cup coconut cream
- ½ cup vanilla coconut yogurt
- ¼ cup powdered sugar
- 1 cup heavy cream
- Zest of 1 lemon
- Pinch turmeric
- Blue and red food coloring

 Active: 30 minutes
Inactive: 3-5 hours Easy

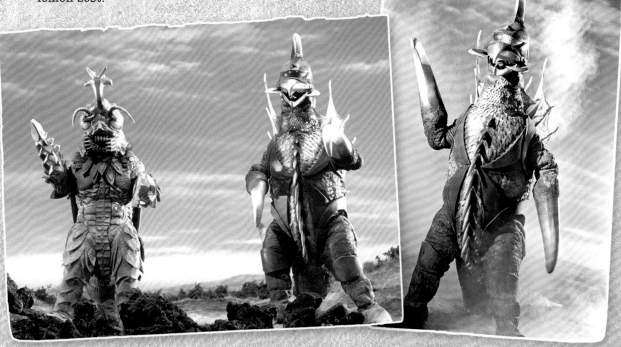

KING CAESAR COOKIES

Coconut is the standout ingredient in these delectable cookies—front and center and flowing, much like the golden chimera locks on the Azumi royal family's kaiju protector.

1. Preheat oven to 375°F. Prepare cookie sheet with cooking spray. In a large bowl, using a hand mixer, cream together the butter, eggs, and sugar until combined.
2. In a food processor, chop up the coconut and lavender leaves until very fine. Add coconut and lavender to the creamed butter and sugar mixture. Sift together flour, baking powder, and salt in a large bowl. Combine both mixtures until completely blended.
3. Using a 2-tbsp cookie scoop, scoop the dough onto the cookie sheet to make 12 cookies. Bake for 12 minutes until edges are golden. Allow to cool.
4. To make the frosting, combine confectioners' sugar, coconut extract, and lemon juice in a medium bowl, and stir until smooth. Once cookies are cool, dip each cookie into the icing, place on wire rack, and sprinkle with toasted coconut and lavender flowers. (Makes 18 cookies)

INGREDIENTS

- 2 eggs (room temperature)
- ½ cup vegan butter (room temperature)
- 1 cup coconut palm sugar
- ½ cup sweetened coconut
- 1 tsp dried lavender flowers
- 1 ½ cups flour
- 1 tsp baking powder
- ¼ tsp salt

Icing:
- ½ cup coconut, toasted
- 1 cup confectioners' sugar
- ½ tsp coconut extract
- 2-3 tbsp lemon juice

 Active: 1 hour Easy Vegetarian

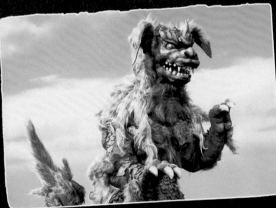

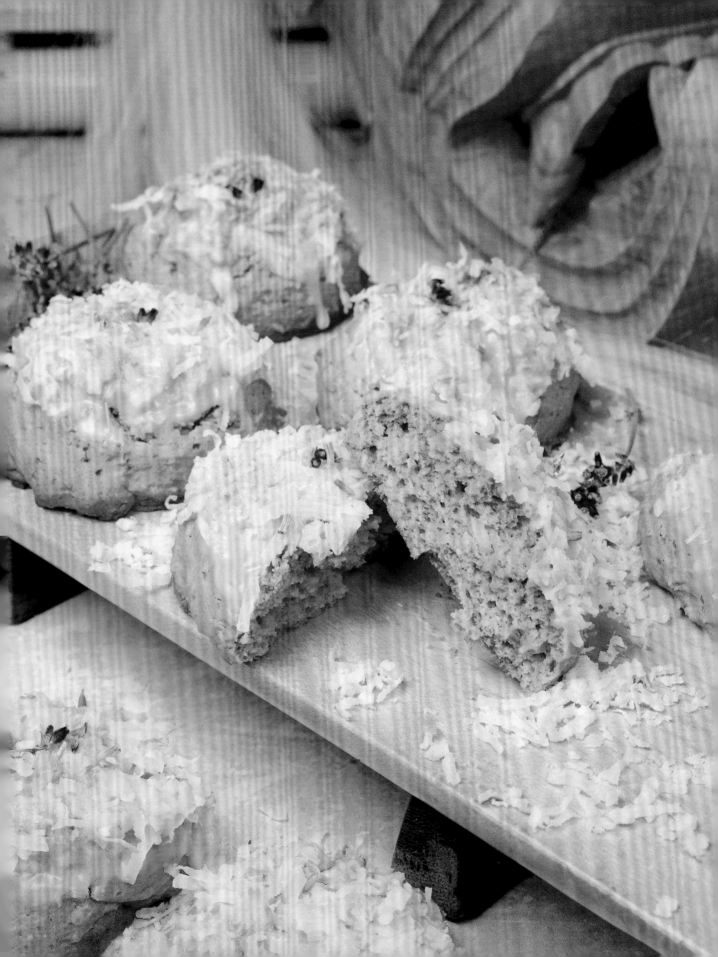

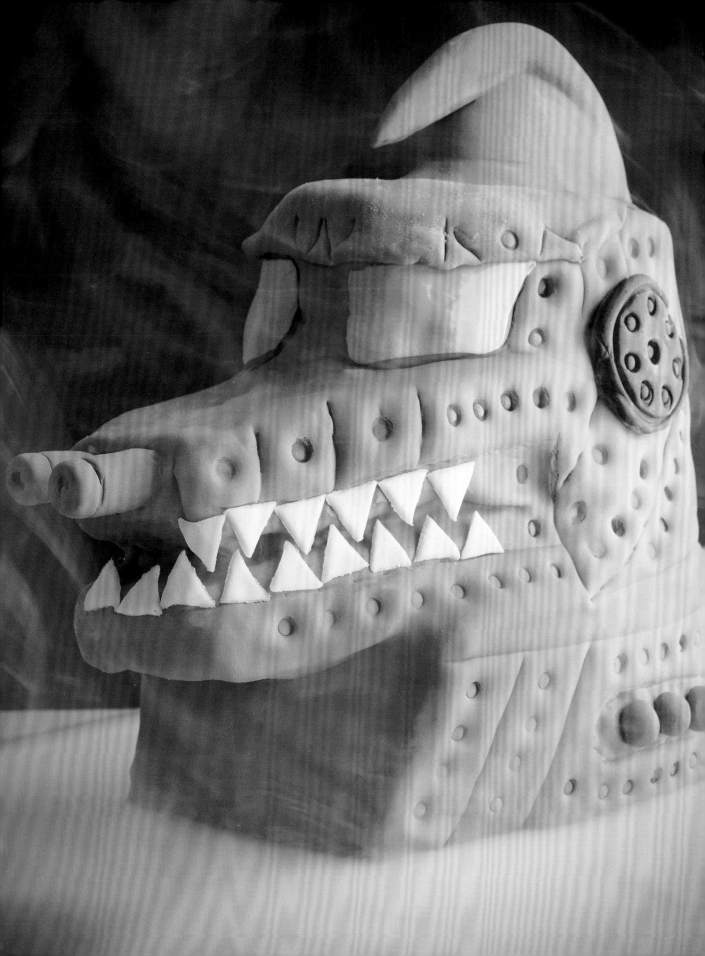

メカゴジラ　ヘッド
MECHAGODZILLA HEAD

You may not have any Space Titanium laying around to build this head with, but thankfully cake works just fine.

 Active: 2 days Complex

1. Be prepared to make these cakes in two batches. Preheat oven to 350°F, grease 4 cake pans (three 8-in pans and one 10-in pan). In a large bowl, combine half the flour, baking powder, lemon zest, and salt, and set aside.

2. In the bowl of a stand mixer using a paddle attachment set on medium high, cream half the butter and sugar together, making sure to scrape all the sides and bottom of the bowl, until pale and fluffy (roughly 10 minutes). Continue by adding half the eggs one at a time until fully combined, mix for 2-3 minutes.

3. Set to low and start adding the flour mixture and sour cream a half at a time until combined. Add half the vanilla extract and lemon juice, mix for 30 seconds until combined. Do not overmix.

4. Add the thick batter to two of the pans halfway (about 1 inch). Bake for 30 minutes or until a toothpick comes out clean. Let the cakes cool slightly in the pan. Transfer the cakes to cooling racks. Allow cakes to cool completely. Repeat all for the other two cakes. Check fridge for an area to place a cake that is 11 in tall (not including cake stand).

5. For buttercream frosting, combine all ingredients in a stand mixer with a paddle attachment on low and mix until fluffy. Trim off the tops of the cakes so that they are flat and not curved.

INGREDIENTS

- 6 cups all-purpose flour
- 6 tsp baking powder
- 4 tbsp lemon zest
- 2 tsp salt
- 2 cups unsalted butter, room temperature
- 4 cups granulated sugar
- 8 large eggs, room temperature
- 4 tsp vanilla extract
- 8 tbsp lemon juice
- 2 cups sour cream

Buttercream frosting:
- 6 cups confectioners' sugar
- 3 cups butter, softened
- 4 ½ tbsp lemon juice
- 3 tbsp almond milk
- 500g vanilla fondant
- Black food coloring
- Red food coloring
- Yellow food coloring
- Confectioners' sugar

Special equipment: Cake-decorating rotating stand, fondant shaping tools, straw, dough scraper, four boba tea straws

Desserts 133

6. On a foil-covered cardboard base placed on a rotating cake decorating stand, add 2 tbsp frosting and place one cake layer to start the build. Frost the top of the cake and add another 8-in cake layer. Slice the 10-in cake in half lengthwise and place centered on the cake base, with 2 inches hanging off one side. Frost the cake top and place the other 10-in half on top of it.

7. Push 2–3 boba tea straws into the cake to keep it stable as you add more layers. Trim off the extra straw with scissors. Cut the remaining 8-in cake in half, frost the top of the cake build, add the 4x8-in layer on top, and then add the last one on top. Make sure everything is stable and place in refrigerator overnight. Store any extra buttercream covered and in the fridge for the next day.

8. When ready to carve, remove cake and buttercream from fridge. With a serrated knife, start to carve the shape of the head, little by little. Keep the extra pieces for the top spike on its head in case you need them.

9. Once you have carved the base, cover with buttercream and smooth out all around the cake. On a cold surface, start to work with the fondant. Use roughly 400g fondant for the grey. Using food-safe gloves and a rolling pin, start by massaging and getting the fondant pliable. Add several drops of black food coloring and work into the fondant until the right shade of grey is achieved.

10. Using a dough scrape, cut the fondant into thirds. If the fondant sticks, use confectioners' sugar to continue working. Roll out one third of the fondant into a layer large enough to cover half the cake. The fondant should be thin (about 1/8-in thick).

11. Cover and smooth the layer, and repeat for the other side with another third of the grey fondant. Keep the other grey for details and possible touch-up on head spike. Take your time and smooth out all the areas you can on the head.

12. Using more white fondant, use two small pieces to create the eyes in yellow and the side panel in red. Use water to moisten and attach fondant to fondant. Use a regular small straw to create the rivet pattern on the head. Shape the front nostrils out of the grey fondant and attach using a piece of wooden skewer.

13. Complete all the remaining pieces out of the remaining grey fondant and, lastly, using a very small amount of white fondant, cut the teeth out in triangle shapes (use water to moisten and attach). And now you are ready to take on all the Earth-bound kaiju!

ジェットジャガーマグケーキ
JET JAGUAR MUGCAKES

GPN news blaring on the radio to get out of town? Run, evacuate the island now! But before you run for your life, why not try this awesome robot-inspired recipe?

Active: 5 minutes　　Easy　　Vegan

1. Add the flour, sugar, baking powder, and salt to a 12-oz mug, and stir together. Stir in coconut milk, melted butter, and almond extract until smooth. Scrape bottom of mug.

2. Add coloring to each third of the mug. Using a skewer, mix in lightly to each third, being careful not to get too much cross-coloring. Cook in microwave for 1 minute and 45 seconds (the cake should still be a little shiny on top). Let rest for another 2 minutes. Using a flexible spatula, de-mug the cake. Sprinkle colored sugar on top to serve. Can also be served in mug. (Serves 1)

INGREDIENTS

- ¼ cup + 3 tsp all-purpose flour
- 2 tbsp sugar
- ¼ tsp baking powder
- 2 tbsp vegan butter, melted
- 4 tbsp coconut milk
- ¼ tsp almond extract
- A few drops of blue, red, and yellow food coloring
- Pinch of salt

SHIBUYA DINER CHERRY PIE

For many news reporters and Tokyo police officers, a diner is always the perfect place to meet, preferably over a slice of pie, some Blue Mountain coffee, and some top-secret information.

1. Preheat oven to 350°F. Grease a 10-in pie pan and place prepared pie crust into pan, pressing on edges to conform to pie pan. With a fork, puncture holes in bottom of pie crust. Set aside.

2. In a large bowl, add cherries, cranberries, sugar, cornstarch, yuzu, vanilla extract, and lemon zest, and combine. Let it sit for about 5 minutes. Add mixture to a medium saucepan and cook on medium heat for 5–8 minutes until mixture begins to thicken. Remove from heat and set aside.

3. Meanwhile, in a medium bowl, combine the walnuts, coconut palm sugar, rolled oats, flour and salt. Using a food-safe glove, add the cubed cold butter and massage the butter into the walnut mixture to make a clumpy topping. Add the thickened cherry/cranberry pie filling to the pie pan.

4. Top with walnut mixture and bake for 45 minutes or until cherries bubble and topping is crisp. Remove from oven and let cool for 1 hour or more. Serve with fresh whipped cream and Blue Mountain Chocolate Coffee (see page 37). (Serves 8)

INGREDIENTS

- 1 store-bought pie crust
- 3 cups cherries, washed and pitted
- 2 cups cranberries, washed and sorted
- ⅓ cup cornstarch
- 1 tbsp yuzu juice
- ¾ cup sugar
- 1 tsp lemon zest
- 1 tsp vanilla extract
- ½ cup butter, cold and cubed
- 1 cup walnuts, chopped
- ½ cup coconut palm sugar
- ½ cup rolled oats
- ¼ cup flour
- ¼ tsp salt

 Active: 2 hours Easy Vegan

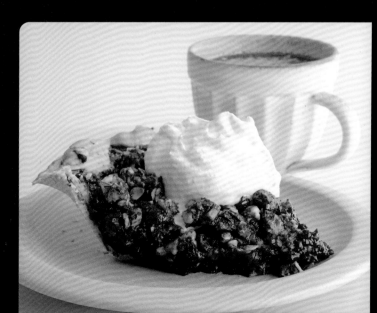

オーシャン デプス プリン
OCEAN DEPTHS PUDDING

The King of the Monsters always rises from the ocean...

1. Add 6 cups water to a medium saucepan and bring to a boil. Add the tapioca pearls, bring to a boil, reduce heat to medium, cover and cook for 30 minutes. Remove from heat and let sit covered for 20 minutes. Drain in colander and rinse with cold water.

2. In a medium bowl, add sugar and 2 cups cold water, dissolve sugar, then add the pearls to the bowl, stir to coat. Bring 2 cups water to a boil and dissolve Jell-O contents. Add a rolled-up clean dish towel to a baking dish and place serving cups or glasses at an angle. Transfer Jell-O to 6 serving cups or glasses.

3. Put in refrigerator for 40 minutes, remove and add tapioca pearls or Boba Tea pearls to the Jell-O. Return to the fridge for another hour.

4. In the meantime, boil 1 cup of water and, in a 4-cup measuring cup, dissolve the gelatin. Let stand until cool to the touch. Whisk in the condensed milk. Remove Jell-O from fridge and top off dessert with the condensed milk/gelatin mixture. Place back in fridge, let them set for at least another 2 hours. Serve with whipped cream. (Serves 6)

INGREDIENTS

- 1 cup large tapioca pearls (or Boba Tea pearls)
- 1 tbsp sugar
- 1 packet of blue Jell-O
- 1 packet of flavorless gelatin
- 1 14-oz can of sweetened condensed milk

 Active: 3-4 hours Easy

モスラの幼虫ケーキ

MOTHRA LARVA CAKE

Our Infant Island kaiju savior comes in many forms: egg, winged, and of course caterpillar. Just like Mothra's multiple forms, this cake takes some time and has multiple steps, but ultimately is beautiful!

1. Prepare a rectangular cookie sheet with parchment paper. Preheat oven to 325°F. In a stand mixer bowl, combine the milk and oil. Sift in the flours, 2 tbsp matcha powder, and salt. With the paddle attachment on, place bowl in mixer and set mixer to medium to combine ingredients.

2. Separate the egg yolks and whites, and keep the whites in a separate medium mixing bowl. Add the yolks to the stand mixing bowl, mix on medium until combined. Using a spatula, scrape the sides and continue mixing until fully combined. Mix in the yuzu juice.

3. Using a hand mixer and a whipping attachment, make a meringue by combining ½ cup of sugar and the egg whites and beating them until they triple in size and you have a silky meringue. Fold the meringue into the batter and combine completely. Pour batter into prepared cookie sheet and bake for 30-35 minutes.

4. Remove from oven and allow to cool in pan for 15 minutes. Carefully lift up from parchment and roll cake lightly to make certain it can roll into a cylindrical form. Release carefully and place in refrigerator to cool completely for 30 minutes.

5. Meanwhile, in the stand mixer, add the cheese, 4 tbsp matcha powder, ½ cup sugar, heavy cream, and almond extract and, using the paddle attachment, mix together, scraping the sides down as needed. Fold in the chopped macadamia nuts.

6. Remove the cake from the refrigerator and, using a spatula, cover the inside of the cake with the cream mixture up to about 2 inches from the top edge, and carefully roll the cake with the cream inside, using the parchment paper. Roll it nice and tight, place back in the refrigerator, and allow to chill for 3 hours.

7. Make the web by adding the ingredients to a small saucepan, heat on low-medium heat, and let it get to 250°F or until the mixture starts to just turn color. Remove from heat, let stand for 3 minutes. Set up parchment paper and, with a spoon, dip into the sugar mixture and drizzle on the parchment to make your own web creations. Allow to cool for 30 minutes or more before removing from parchment. Remove cake from fridge, slice, dust with matcha powder, and decorate with web. (Serves 12)

 Active: 5 hours Complex

INGREDIENTS

Cake:

- 6 tbsp coconut milk
- 4 tbsp coconut oil
- ½ cup cake flour
- 4 tbsp all-purpose flour
- ½ tsp salt
- 6 eggs
- 2 tbsp yuzu juice
- 2 tbsp matcha powder (plus extra for dusting)
- ½ cup sugar

Cream:

- 2 cups heavy cream
- ½ cup chopped macadamia nuts
- 2 tsp almond extract
- 1 cup mascarpone cheese
- 1 cup sugar
- 4 tbsp matcha powder

Web:

- ½ cup sugar
- ¼ cup water
- ¼ cup light corn syrup

SHOBIJIN HATS

While these two keepers of Mothra are miniature in scale, their telepathic strengths are gargantuan. (Also of note, they have a perfect sense of style.)

1. In a mixing cup, combine gelatin with a half cup of cold water, add the vanilla extract and set aside. In a food processor, grind the sugar and sage leaves until it looks like a paste.

2. In a large saucepan, mix the sage paste, a half cup of cold water, corn syrup, and salt. Cook over low heat, and stir until it comes to a simmer (roughly 7 minutes). Increase heat to medium and, using a candy thermometer to measure, simmer until the syrupy mixture reaches 250°F.

3. Remove syrup from the stove and pour mixture into a stand mixer bowl. Clip the thermometer to the bowl and let stand until syrup reaches 210°F. Fix a whisk attachment to the stand mixer and add the gelatin, whisk on low until gelatin is combined with the syrup, and then switch to medium speed. Continue to whip until mixture has fluffed up and is beginning to stick to the whisk.

4. Using cooking spray, grease a 7-in square cakepan and transfer the marshmallow into the pan. Cover with plastic and refrigerate for 5 hours.

5. Dust a cutting surface with confectioners' sugar, remove marshmallow tray from refrigerator, remove plastic, and dust the top of the marshmallow with confectioners' sugar. Using a sharp knife, cut around the edges of the pan and flip the mallow onto the cutting surface. Dust more sugar on the bottom of the candy.

6. Using the circular mold, cut out circular shapes, immediately add them to a resealable bag, and add more confectioners' sugar. Shake the marshmallow in the sugar to completely coat. Remove and place on serving dish. Using a star piping tip, dot the Shobijin hats with frosting.

INGREDIENTS

- 6 tsp unflavored gelatin
- 1 ½ tsp vanilla extract
- 1 ¾ cups granulated sugar
- ½ cup fresh sage leaves
- ½ cup light corn syrup
- ¼ tsp salt
- ½ cup confectioners' sugar for dusting
- Pink frosting

Special equipment: 2-in circular mold, frosting bag and star tip

Active: 30 minutes
Inactive: 5 hours

Easy

ロケット クラッシュ
ROCKET CRASH

If it's not meteorites or aliens that are crashing to Earth, it's spaceships.

1. Combine black cherry juice and cornstarch together and set aside. In a medium saucepan, combine all the fruits, lemon juice, and sugar, and set over low-medium heat. Cook while stirring occasionally until fruits and sugar have combined and mixture is bubbly.
2. Add the cornstarch and cherry juice mixture and stir until mixture is thick and shiny (about 1-2 minutes). Do not overcook. Remove from heat immediately and transfer to a serving bowl or glasses to cool. Refrigerate and when ready to serve add whipped cream to the top. (Serves 4)

INGREDIENTS

- 1 cup chopped black cherries
- 2 cups red currants
- ½ cup black currants
- 1 cup raspberries
- ½ cup sugar
- ⅓ cup cornstarch
- 1 tbsp lemon juice
- 1 cup black cherry juice
- Whipped cream

 Active: 1 hour Easy Vegetarian

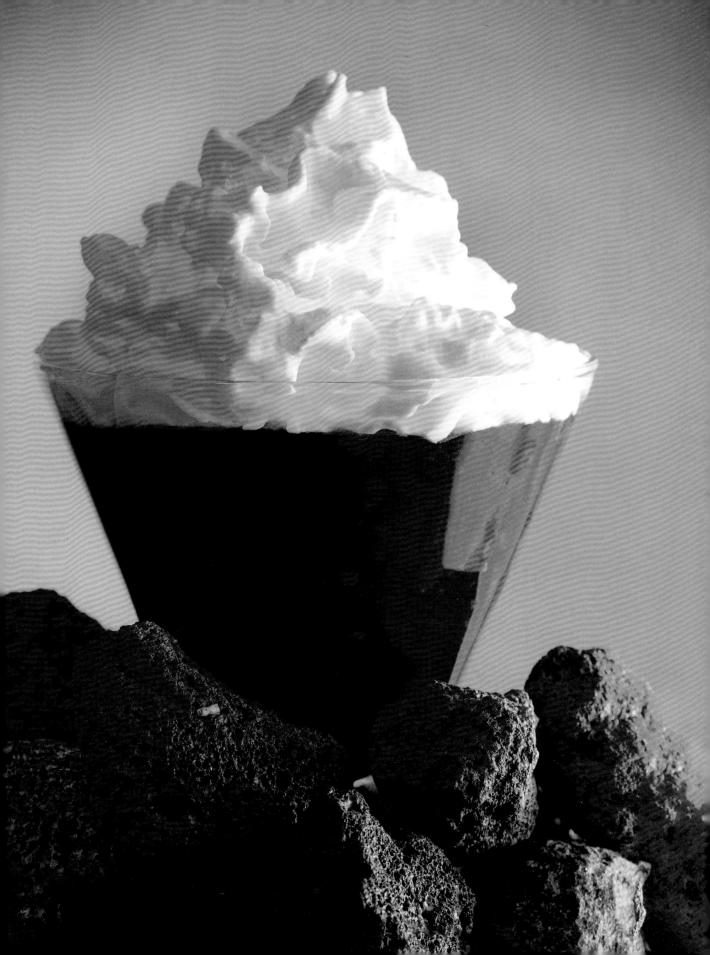

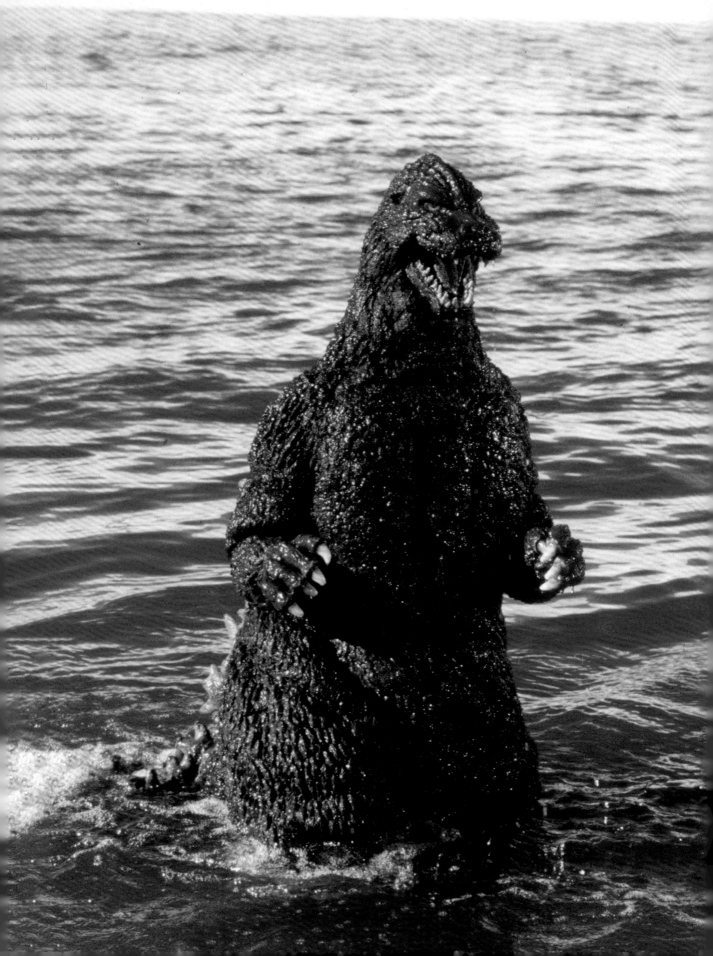

ソースとドレッシング

SAUCES AND DRESSINGS

MONARCH

Kaiju-[Godzilla]
Sample-[Blood]
Location-[Tokyo/Japan]

ゴジラソース
GODZILLA SAUCE

Discard all the stems and seeds from the peppers. Add ½ cup peanut oil to a medium saucepan and heat up over low-medium heat. Press the garlic through a garlic press into the oil, cook for about 2 minutes, then remove from heat and add to blender. Add the other half cup of peanut oil to the saucepan and add the peppers, peanuts, and pumpkin seeds. Cook together for 3 minutes. Remove from heat and add to blender. Add all the other ingredients to the blender and process until smooth.

INGREDIENTS

- 10 chiles de arbol
- 1 cup peanut oil
- 2 tbsp agave syrup
- 12 garlic cloves
- ½ cup raw, shelled, unsalted peanuts
- 2 tbsp raw, unsalted pumpkin seeds
- 1 tbsp sesame seeds
- 1 tbsp apple cider vinegar
- ½ tsp sea salt

 Active: 20 minutes

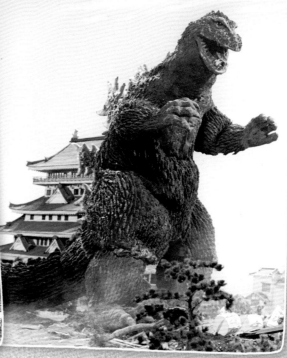

カイジュウソース

KAIJU SAUCE

Add all ingredients to a small food processor. Process until smooth.

INGREDIENTS

- 3 tbsp coconut palm sugar
- 1 tbsp soy sauce
- 1 tsp coconut aminos
- 1 large chipotle pepper in adobo
- ¼ cup apple cider vinegar
- ½ cup ketchup

 Active: 5 minutes

ゆずソース

YUZU SAUCE

Combine the coconut water and cornstarch in a small bowl and set aside. Stir together the sugar, salt, and curry powder in a medium saucepan over low heat. Add in the coconut water slurry, butter, lemon juice, yuzu, and zest, stir over low heat until thickened. Remove from heat and set aside to cool.

 Active: 15 minutes

INGREDIENTS

- 2 tbsp lemon juice
- 1 tbsp yuzu juice
- ⅛ tsp yellow curry powder
- ½ tbsp cornstarch
- ¼ cup sugar
- 2 tbsp butter
- Zest of half a lemon
- ½ cup coconut water
- Dash of salt

天ぷらドレッシング

TEMPURA SAUCE

In a small saucepan, heat up 1 cup water and dashi powder, bring to boil to make dashi stock. Remove from heat and add the rest of the ingredients. Mix together and set aside to cool.

INGREDIENTS

- 1 tsp dashi powder
- ¼ cup mirin
- ¼ cup soy sauce
- ½ tbsp agave syrup

 Active: 20 minutes

餃子のつけダレ

GYOZA DIPPING SAUCE

In a small bowl, whisk all ingredients together and serve with gyoza.

INGREDIENTS

- 1 tbsp soy sauce
- 1 tsp rice wine vinegar
- 1 tsp sesame oil
- 1 tsp chili oil
- 1 tsp agave syrup
- 1 tsp minced ginger and garlic

 Active: 5 minutes

マヨソース
MAYO SAUCE

Combine all ingredients and serve with salads.

INGREDIENTS

- ½ cup Japanese mayo
- 1 tsp coconut aminos
- 1 tsp garlic, minced
- 1 tsp parsley, minced
- 1 tsp lemon juice
- 1 tsp chives, minced

 Active: 5 minutes

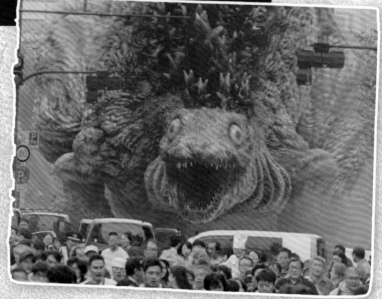

ゴマドレッシング
SESAME DRESSING

Peel and chop all vegetables. Add to a food processor, along with all other ingredients. Process on high until it reaches a nice thick consistency.

INGREDIENTS

- 4 large heirloom carrots (all colors)
- ¼ cup red onion
- 3 tbsp ginger
- 3 tbsp agave syrup
- ¼ cup soy sauce
- ¾ cup rice vinegar
- ½ cup sesame oil

 Active: 15 minutes

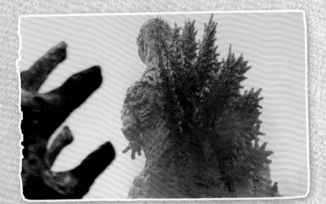

たこ焼きソース
TAKOYAKI SAUCE

Whisk all ingredients together and serve over takoyaki.

INGREDIENTS

- 3 tbsp coconut aminos
- 1 tsp Mentsuyu soup base
- 1 tsp agave syrup
- 1 tsp ketchup
- 1 tbsp oyster sauce

 Active: 5 minutes

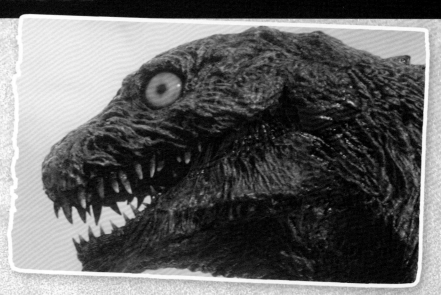

カブの浅漬け
PICKLED TURNIPS

In a small saucepan, add 1 ½ cups water and bring to a boil. Remove from heat, add sugar and salt, and stir to dissolve. Add in the vinegar, oregano, garlic, and bay leaves, and stir. In a large glass, sealable, pickling container, add in the beets first and then the turnips. Pour in hot liquid mixture to cover. Let stand for about 30 minutes, cover container and allow to pickle for 4-6 days in a dark location. Refrigerate after opening and use within 2 weeks.

INGREDIENTS

- ½ cup apple cider vinegar
- 2 tbsp kosher salt
- 1 tbsp granulated sugar
- 2 large garlic cloves, peeled and smashed
- 1 tsp dried oregano
- 2 bay leaves
- 1 lb turnips, peeled and cut into ½-inch-thick pieces
- 1 small beet, sliced

照り焼きグレイズ
TERIYAKI GLAZE

In a small saucepan over medium heat, combine 1 cup water, soy sauce, agave syrup, brown sugar, ginger, garlic powder, and guajillo powder. Whisk together and bring to a boil, cook for 2 minutes. In a measuring cup, dissolve cornstarch in ¼ cup of water. Add to the saucepan and continue cooking until thickened (about 2 minutes).

 Active: 20 minutes

INGREDIENTS

- ¼ cup soy sauce
- ¼ cup agave syrup
- 1 tbsp brown sugar
- ½ tsp fresh ginger, grated
- ¼ tsp garlic powder
- ½ tsp guajillo powder
- 2 tbsp cornstarch

ガーリック ソース
GARLIC SAUCE

Peel and cut potato into 2-inch pieces. In a medium saucepan, add potato to salted water and bring to boil, reduce heat to medium and continue to cook until completely tender. Drain potato. Over a large bowl, place potato pieces into potato ricer to process into mash. Set aside. In a food processor, add garlic, salt, ¼-cup of oil, and half the lemon juice. Process until smooth. Turn processor off and add half of the mashed potato, process, and drizzle in half the remaining oil and lemon juice. Continue and add the rest of the mashed potato, oil and lemon juice, process till smooth. Check for seasoning, transfer to airtight container, and refrigerate for at least an hour before using.

INGREDIENTS

- ½ cup fresh garlic cloves, peeled
- 1 russet potato
- 1 tsp salt
- ½ cup sunflower oil
- ¼ cup lemon juice

 Active: 30 minutes

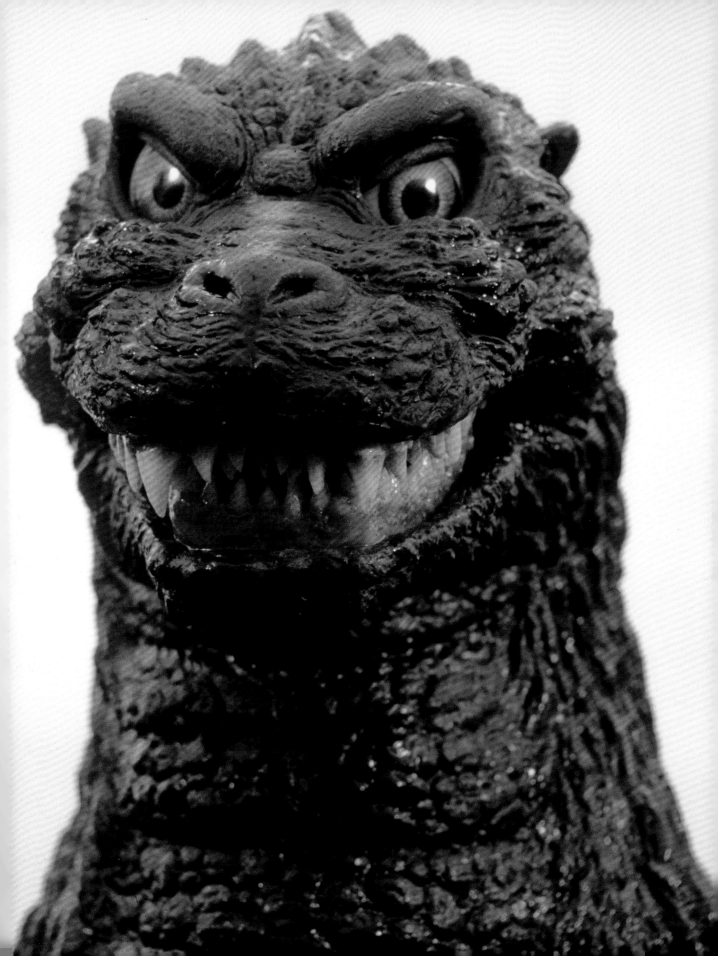

COOKING IN A KAIJU WORLD

While either preparing to run from the monstrous destruction around the city or just awaiting the next earth-trembling tell-tale sign of an impending battle, planning your next meal can be challenging. That is why there are a variety of dishes in this book that are as varied as they are delicious, including vegan and vegetarian dishes, as well as many that take their inspiration from the sea.

Most of the recipes include Japanese-inspired flavors and ingredients, but there are many that take their cues from other worldly cuisines. Regardless of their origin, while Godzilla and his friends trample around, gathering ingredients and cooking a meal can sometimes be a tricky task. So here are some tips to getting a meal on the table during monstrous times.

Read the recipe in its entirety before starting. It's important to know the ingredients, but even more important to know the steps, process and time it will take to complete a meal. The last thing anyone wants to do is to start a meal and then have to run for your life mid-prep.

While most ingredients can be found at the local market, those stores may have been abandoned by the locals during a kaiju battle. Most Asian markets will have the ingredients you seek, or will be able to order them for you. Sourcing ingredients online can be helpful for those hard-to-find items.

While there are a variety of recipes in this book, sometimes there are ingredients that just don't sit well with many. It is always good to try different things and to be creative—after all, when having your town destroyed by King Ghidorah, sometimes you must cook with what you have. Just remember—if substituting ingredients, times and quantities may vary to get the same result. And when it comes to baking, please be mindful that exact measurements are key to yielding good results.

Overall, enjoy the meals you make, get creative, and make sure you have enough time to make them before the Godzilla siren goes off and you must evacuate the building!

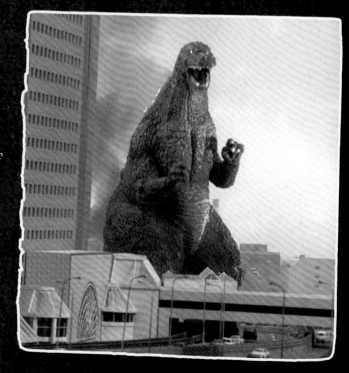

換算表
CONVERSION TABLES

VOLUME

IMPERIAL	CUPS	METRIC
-	¼ tsp	1.25ml
-	½ tsp	2.5ml
-	1 tsp	5ml
-	1 Tbsp	15ml
3 ½ fl oz	-	100ml
4 ½ fl oz	½ cup	125ml
5 fl oz	-	150ml
7 fl oz	-	200ml
9 fl oz	1 cup	250ml
11 fl oz	-	300ml
14 fl oz	-	400ml
18 fl oz	2 cups	500ml
26 fl oz	3 cups	750ml
35 fl oz	4 cups	1L
53 fl oz	6 cups	1.5L
70 fl oz	8 cups	2L

WEIGHT

IMPERIAL	METRIC
½ oz	15g
1 oz	30g
2 oz	60g
3 oz	85g
4 oz (¼ lb)	115g
5 oz	140g
6 oz	170g
7 oz	200g
8 oz (½ lb)	230g
16 oz (1 lb)	450g
32 oz (2 lb)	950g
35 oz (2 ⅕ lb)	1kg

TEMPERATURE

FAHRENHEIT	CELSIUS	GAS
250°F	120°C	½
275°F	140°C	1
300°F	150°C	2
325°F	160°C	3
350°F	180°C	4
375°F	190°C	5
400°F	200°C	6
425°F	220°C	7
450°F	230°C	8
475°F	240°C	9
500°F	260°C	10

LENGTH

IMPERIAL	METRIC
¼ in	6mm
½ in	13mm
1 in	25mm
2 in	51mm
1 ft	305mm
1 ft 8in	500mm
1 yard	915mm
3 ft 3 in	1000mm

MONSTER MENU IDEAS

Planning on a kaiju-sized viewing party of your favorite Godzilla movies? Want to make a monster impression on your guests? Well, here are a few menu suggestions that are sure to be a big hit (without the destruction).

モトラ・メニュー

MOTHRA MENU

Spread your culinary wings as you prepare this Mothra-themed menu in honor of one of Godzilla's closest allies. Most of this can be made on the day, but making those cute Shobijin Hats a day in advance is crucial for that end-of-movie treat.

- Mothra Wings
- Mothra Eggs
- Kaiju Tempura
- Shobijin Hats

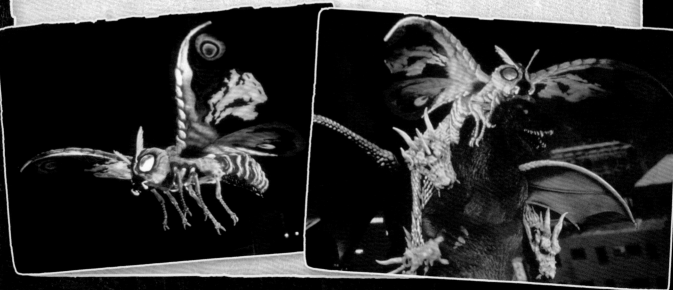

ゴジラマラソン

GODZILLA MARATHON

If you're going to go for the full Godzilla
marathon, it's best you keep up your
energy with the big guy's Energy Boost.
Bake some Rodan Beaks the day before
and wow your guests the day of your movie
marathon with your Godzilla foot-sculpting
skills. Rounding out your menu with King
Ghidorah Dip and Monster Island Salad
should keep everyone energized all the
way to the colossal conclusion!

- Godzilla's Energy Boost
- King Ghidorah Dip
- Godzilla Loaf
- Monster Island Salad
- Rodan Beaks

エビラ、深海の恐怖

EBIRAH, HORROR OF THE DEEP

This deep-sea kaiju movie certainly lends
itself to some monstrously delectable dishes.
Preparing your cake and appetizer a day ahead
is best, as is starting off your viewing party with
a banana-themed cocktail.

- The Letchi
- Ebirah Claw Cocktail
- Ebirah Claws
- Infant Island Rice
- Red Bamboo Cake

アクノレッジメント
ACKNOWLEDGMENTS

I am so eternally grateful to Bob for being my life, my love, my taste tester and just the best human. He is also my Tokyo travel buddy to whom I owe so many incredible food tasting experiences. A heartfelt thank you to my friend Jorge Montero for the wonderful Godzilla props. And of course, a kaiju-sized thanks to all the Gatos from our little Gato Pub community for being the coolest cats around and for being there when I needed them most.